Picture This

		v
	*	
	*.	

Picture This

How Pictures Work

Revised and Expanded 25th Anniversary Edition

Molly Bang

CHRONICLE BOOKS

Copyright © 1991, 2016 by Molly Bang.

All rights reserved. No part of this book may be reproduced in any form without written permission from the publisher.

Library of Congress Cataloging-in-Publication Data:

Bang, Molly, author.

 $Picture\ this: how\ pictures\ work\ /\ Molly\ Bang.\ -Revised\ and\ Expanded\ 25th\ Anniversary\ Edition.$

pages cm

"First published as Picture This: Perception and Composition by Bullfinch Press/Little, Brown and Company, Boston, 1991."

ISBN 978-1-4521-3515-1 [hardcover]

ISBN 978-1-4521-5199-1 [paperback]

1. Visual perception. 2. Design. I. Title.

NK1510.B258 2016

741.6'74-dc23

2015036410

Manufactured in China.

Design by Amelia Mack.

Typeset in Nobel Book and Bodoni Egyptian.

10987654321

Chronicle Books LLC 680 Second Street San Francisco, CA 94107

www.chroniclebooks.com

To Leon and Monika, who both started it all, to Jim and Penny, my constant superb critics and consultants, to Melissa Manlove and David Macaulay, who filled me with amazed gratitude, and with special thanks to Dick

Contents

Preface xii

Building the Emotional Content of Pictures 1

The Principles 51

From Intent to Execution 114

Finally, in Defense of Instinct 125

Now...Begin 126

Preface

I was quite happily making my living as a writer and illustrator of children's books. One day I was sketching objects around the house while an old friend, Leon Shiman, was visiting. Leon suggested I draw not just isolated objects, but whole views, whole pictures. The more I drew, the more I knew I was lost. As we looked at the sketches together and talked about them, Leon said, "You really don't understand how pictures work, do you?"

No, I did not. I didn't understand picture structure. I didn't even understand what "picture structure" meant. But could I learn?

I took a painting course with Sava Morgan, an artist who had taught for years in New York City. I read books on art and on the psychology of art. I went to museums and galleries to look at paintings and try to figure out what I felt about them and what the paintings were doing. And I decided to make pictures with my daughter's third grade class, hoping I'd learn something from teaching—as one often does.

Working with the children, I realized that I wanted to make pictures with clearly different emotions, but I also wanted to stay very simple. I decided to build an illustration from "Little Red Riding Hood," since this story was familiar to everybody, and I knew I could make a scary wolf from a few sharp triangles. But I had to make a comforting picture first, to contrast with the scary wolf. I used simple shapes cut from four colors of construction paper—red, black, pale purple, and white. As the children gave me directions for how to make a picture scarier or more comforting, we realized something we already knew—something about pictures and feelings. We just hadn't defined it yet.

This was not a particularly helpful project for the third grade. They felt that cutting paper was too much like kindergarten, and they were third graders! They wanted to learn how to make things look

real. But I knew I was on to something, so I took my scissors and my construction paper home and kept cutting, arranging, looking, and thinking. I began to see how certain elements in pictures affect our feelings.

Pretty soon I wanted to see if other people could apply to their own pictures the principles I had uncovered. It was clear that younger children understood them but were not particularly interested in this mix of geometrical abstraction and emotional expression, so I taught eighth and ninth graders and then adults. The pictures they made convinced me that anyone and everyone could use a few clear principles to build powerful visual statements: emotionally charged arrangements of shapes on a page.

I wrote up what seemed to be going on, then sent it to Rudolf Arnheim, the dean of the psychology of art in the United States, whose books I had found most helpful. Almost immediately I received a courtly letter back saying that he liked the book and had some suggestions if I didn't mind his scribbling on the sides of the pages. Mind? I asked him to please scribble, scribble away. He returned the manuscript with comments on almost every page, each one insightful or illuminating, and I incorporated every one.

Now, I felt I'd found something pretty fundamental here, but I didn't quite know what it was, so when I sent Arnheim the revised text I asked him if he could tell me what I'd done. He wrote,

What is . . . so special and striking about the style of your book is that it uses geometrical shapes not as geometry, which would not be all that new, not as pure percepts in the sense of psychology textbooks, but entirely as dynamic expression. You are talking about a play of dramatic visual forces, presenting such features as size or direction or contrast as the actions of which natural and human behavior is constituted. This makes your story so alive on each page. It gives to all its shapes the strength of puppets or primitive wood carvings, not giving up abstractness but on the contrary exploiting its elementary powers. . . . You are [also] taking the prettiness of the nursery out of the fairy tale story and reducing it to the basic sensations, taking the childlike-ness out of it but leaving and even enforcing the basic human action that

derives from the direct visual sensation. It is what remains of "Red Riding Hood" if you take the prettiness out of it and leave the stark sensations we experience when we rely on direct and pure looking.

This was exciting. Even if I didn't exactly understand what it meant, it corroborated what I'd felt all along: I had understood some basic connection between emotions and how we see pictures. I've since thought and thought about Arnheim's answer and about what I'd felt from watching the principles appear and the book take form. For me, the book explores one question and only one question:

How does the structure of a picture—or any visual art form—affect our emotional response?

Building the Emotional Content of Pictures

We see shapes in context,

and our reactions to them depend in large part on that context. If this were an illustration for a story about the ocean, we could variously read the red triangle as the sail of a sailboat, a shark's fin, a volcanic island rising from the sea, a "red nun" buoy, or the bow of a sinking ship. We feel very differently about the triangle if we see it as a sailboat than we do if we see it as a shark's fin.

But I thought of all this much later. I first decided to represent Little Red Riding Hood as a little red triangle and then asked myself, "Do I feel anything for this shape?" The figure is not exactly fraught with emotion, yet I knew I felt things about it that I didn't feel for others.

It isn't huggable. Why not? Because it has points. It makes me feel stable. Why? It has a flat, wide, horizontal base. It gives a sense of equanimity, or balance, as well, because its three sides are equal. If it were sharper, it would feel nastier; if it were flatter, it would feel more immobile; and if it were an irregular triangle, I would feel off balance. What about its color? We call red a warm color, bold, flashy; I feel danger, vitality, passion. How can one color evoke such a range of disparate, even conflicting, feelings?

What is red? Blood and fire. Ah. The feelings evoked in me by red all seem to be associated with these two things that have been red and only red ever since humans have been around to see them. Could the emotions brought by red be a mixture of my feelings about blood and fire? So far, they certainly seem to be.

These, then, are the feelings I have for this medium-size red triangle: stability, balance, a prickliness or alertness, plus warmth, strength, vitality, boldness, and perhaps some sense of danger. Now let me look at the triangle as Little Red Riding Hood. The shape and color, of course, relate to her clothes, but can I apply the feelings I have about her as a red triangle to her as a person? Yes: the figure suggests a character who is alert, warm, strong, stable, balanced, vital, and with perhaps some sense of danger.

If a red triangle represents Little Red Riding Hood, how might I show her mother?

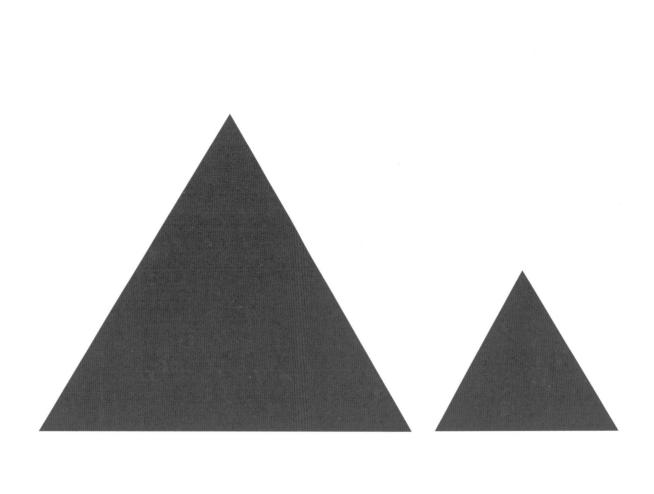

I could simply show her mother as a bigger red triangle, a bigger version of Little Red Riding Hood.

But what has happened?

The mother has become the more important object in the picture and now overwhelms her daughter. Little Red Riding Hood no longer appears to be the main protagonist. In addition, though this shape implies a mother who is warm and strong and vital, she is also overbearing and decidedly not huggable.

How can I make her feel less overwhelming and more huggable?

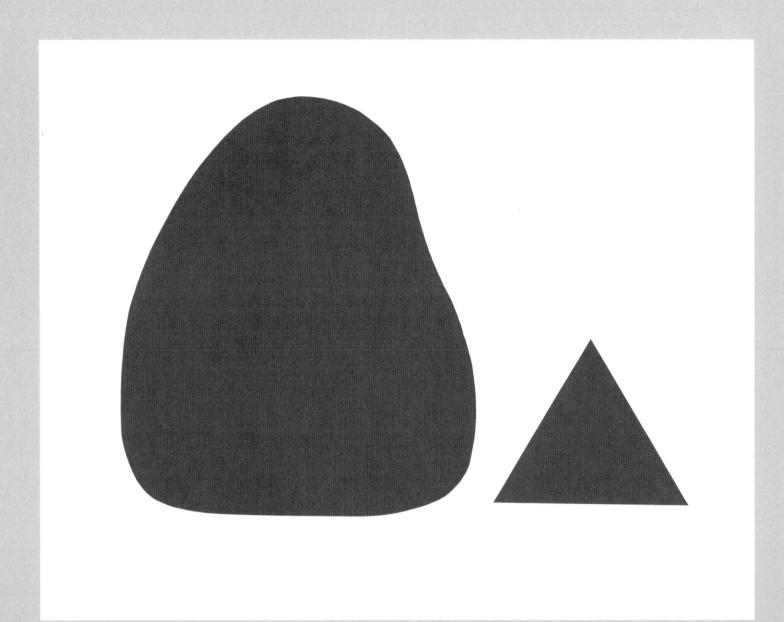

If I keep her triangular shape but round off her corners, she does seem softer. But she still takes over the picture. She draws attention away from the heroine, Little Red Riding Hood, because she is a bigger mass of red.

How can I keep her large (since mothers are larger than their young daughters) but give Little Red Riding Hood prominence in the picture?

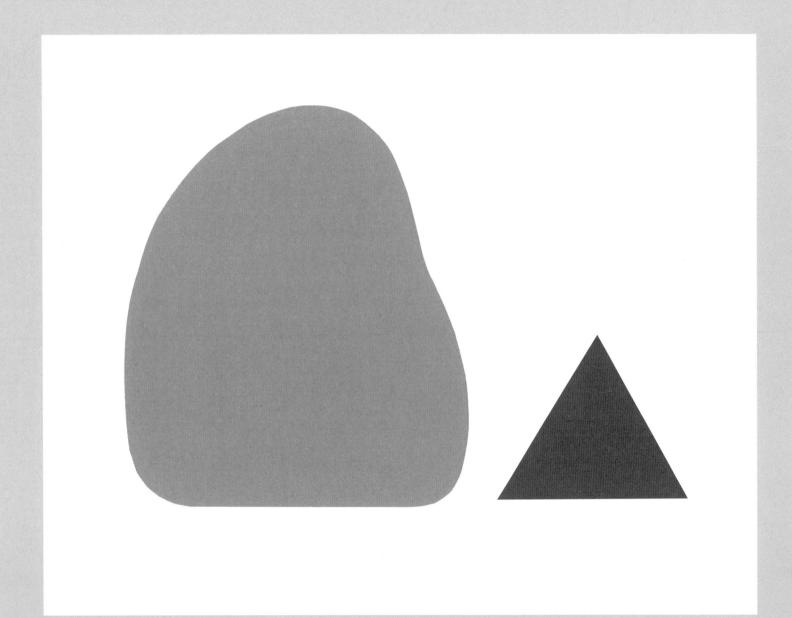

If I make her a pale color, she and her daughter are more equal in the picture. Little Red Riding Hood feels comparatively bold, active, and more interesting.

The mother could just as easily have been made pale blue or pale green, but then her color would not be at all related to that of Little Red Riding Hood. Since purple has red in it, the mother and daughter are at least slightly related by color as well. They would have been more so if the mother had been pink, but I wanted to restrict the colors to four, and pink, red, black, and white felt too monotone to me.

What do I feel about the mother now?

She seems huggable and stable, though less strong and less warm than before. But she is still motherly, and the emphasis of the picture is now on little Red Riding Hood rather than on her mother. Now that she's the boldest color, she is also clearly the main character in the story.

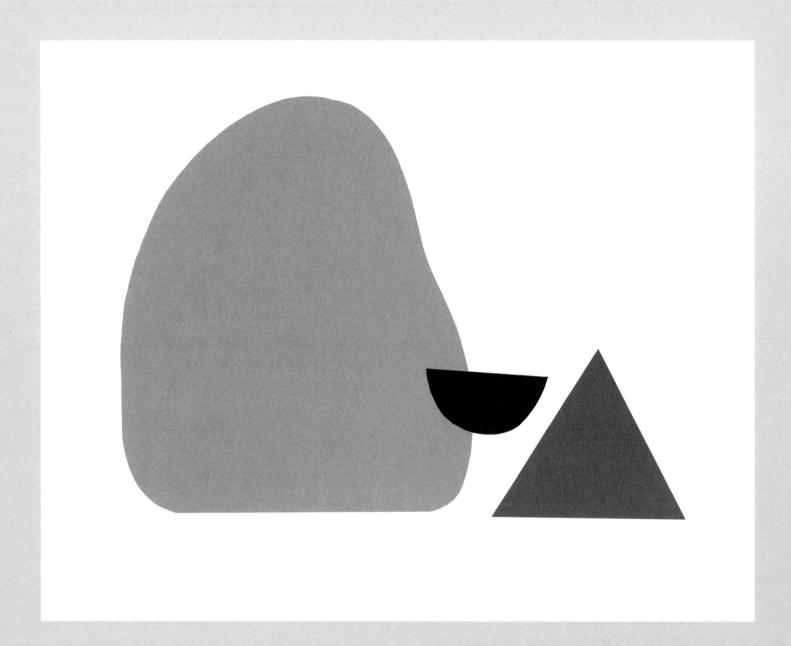

Here is the basket.

I chose black because it drew my attention and because it gave me the widest possible range of feeling. Chartreuse would have been a better complement to the red (and I love chartreuse), but it was too close to the purple in intensity and feeling. Also, I feel I would still have had to add a really dark color to show the scary elements, and I wanted to keep this as simple as possible so I could keep track of what was going on. With these three colors, plus white, I had a wide emotional range, and each color was distinct from the others.

Now, so far this is not the most moving or inspired picture we have ever seen. But it has shown some of the ways that shapes and colors affect us emotionally. It also lays the groundwork for a better understanding of how to go about making the next picture, of

the woods.

I wanted to stay as simple as possible, so I first made the woods with more triangles—both long and pointed individual triangles scattered on the page, or

fatter triangles piled on top of one another. We see them at once as a forest of spruce or fir trees. But these are too close to the shapes of Little Red Riding Hood and her mother. When we see similar shapes in a picture—or in life—we relate those shapes to each other: they seem to belong together. I didn't want to imply that the human beings were turning into trees or the trees into people, or that Little Red Riding Hood particularly belongs in or relates to the woods. To avoid this confusion, and also to get relief from all these triangles, another possibility for the woods is

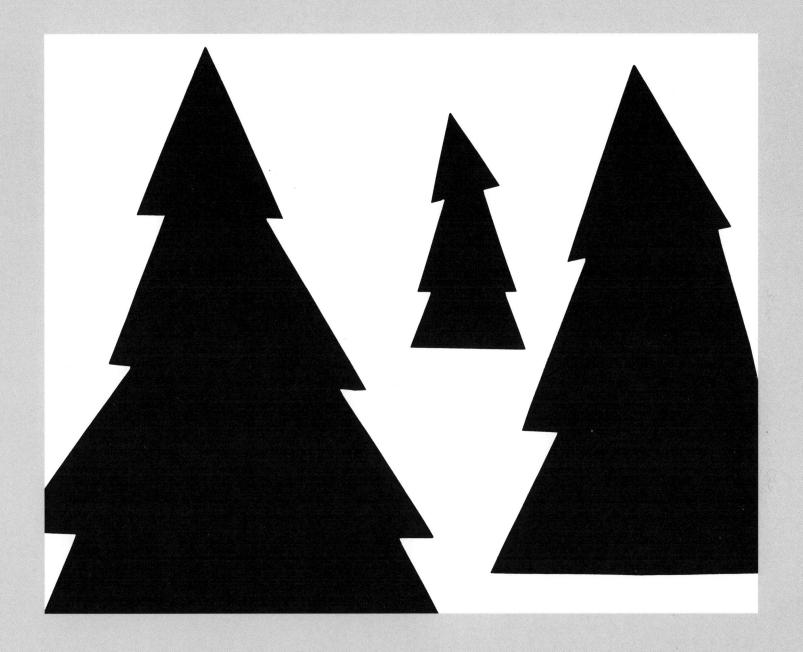

this one.

These are simply long, vertical rectangles of varying lengths and widths, which, in the context of this story, represent branchless tree trunks. Because we can't see their tops, the trees seem very tall. We are now deep in the midst of the woods, as Little Red Riding Hood will have to be.

The trees give the illusion of going back in space. This sense of depth is accomplished simply by arranging the pieces so that the thinner they are, the higher up on the page their bases are placed. Note that the tops of the trees have to go all the way off the top of the picture frame for the illusion to work.

It was when I had made this much of the picture—when I had "set the stage"—that I began to feel more involved; it was time for Little Red Riding Hood to make her entrance into the woods.

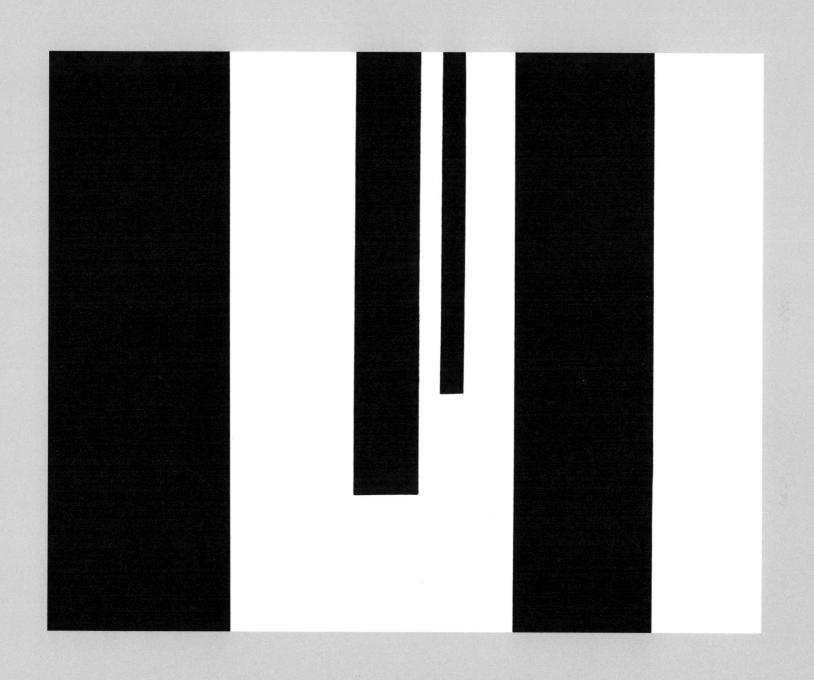

And here she is.

This picture can easily be read as Little Red Riding Hood in the woods, especially since she has been connected with one of the trees and is partly covered by it. This makes her belong and be inside the woods.

It also makes me be inside the woods, as we tend to identify with some specific element in the picture. This was brought home to me when I went to a scary movie with a friend and had to leave at the really scary points. My friend said that at the scary parts, she identified with the monster so she wasn't scared at all. It was also interesting to see that I can comfortably make very scary pictures, as they are my scary pieces, and I'm in control of them.

As soon as I began playing with the figure of Little Red Riding Hood in the woods, I noticed how much I identified with her and "entered the picture."

But the picture should be scarier than this, as these are the woods in which the heroine will meet the wolf who is going to eat her up. I need to imply some threat in her environment. I need to construct a scarier setup even before the introduction of the wolf.

What can I do to Little Red Riding Hood—only to the triangle—to make the picture feel scarier? I could tip the triangle so it isn't so stable, I could cut off more of it with the trees, or

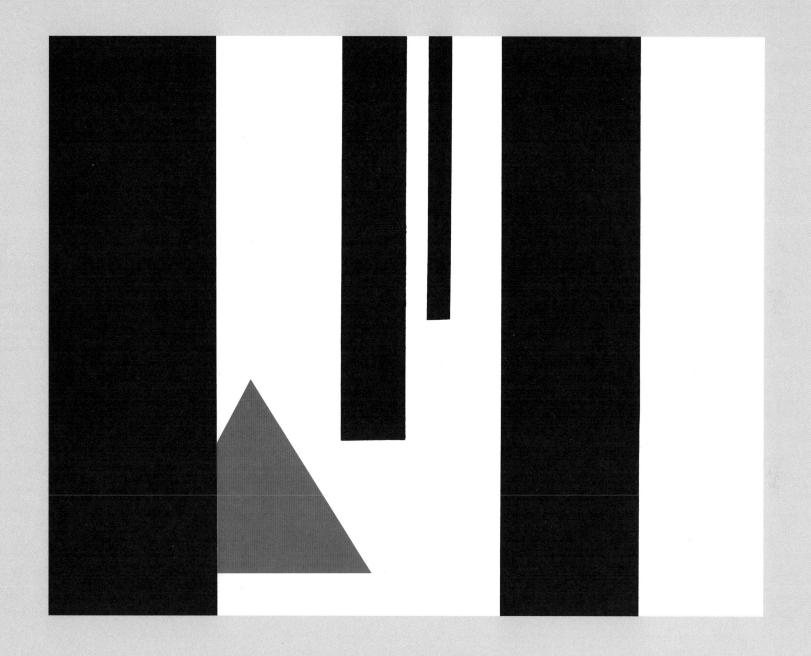

I could make it smaller.

The woods feel somewhat scarier here because they are proportionately larger in relation to the heroine; she is proportionally smaller.

Why does it feel scarier when she is proportionally smaller?

We feel more scared when we are little and an attacker is big, because we're less able to overcome the danger or control it physically. When we are little, we are weaker and can't defend ourselves as well in a physical fight.

I can reduce Little Red Riding Hood still more. Now the trees seem even bigger, and she looks—and we feel—even more overwhelmed by the situation. Also, I have to prepare for the fact that she will not stay alone in the middle of these trees. I need to make room for the wolf.

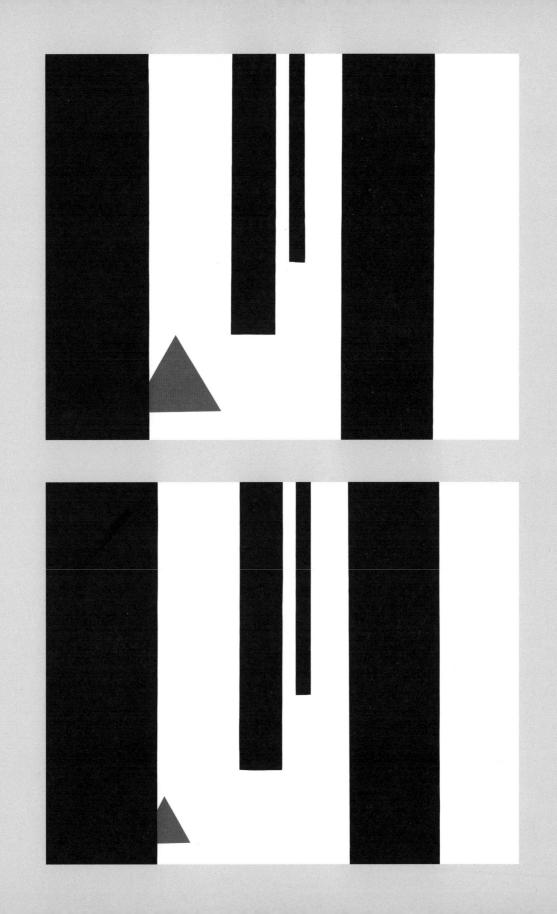

I felt suddenly disappointed when I moved her up, and it took me some time to figure out why.

First of all, she looks smaller and farther away, even though the triangle is exactly the same size as on the previous page. She looks farther away because the trees have established a sense of perspective, of receding space, and Little Red Riding Hood seems to have moved back through the space just by being placed higher up on the page. That's fine.

But the picture doesn't feel as scary as it did before. Why not?

I finally realized that when Little Red Riding Hood is more distant from me, I don't identify with her or sympathize with her so much as before. Distance makes the heart grow colder—not fonder. I feel less close to her, less attached to her. I am outside the picture. I have become an onlooker. Also, the woods are proportionally smaller again.

Before I introduce the wolf, there is another aspect of the picture I can work on to make it feel scarier: the trees. How can I make the trees feel more threatening?

I could add many more of them, to make the woods darker and more like a prison surrounding her. I could add a lot of pointed branches, which would make the picture seem more threatening, since pointed objects feel dangerous.

I tried both of these, and the woods did feel very scary. But the picture became filled up, and when I put the wolf in, it became lost in the confusion. So I cleared almost all the pieces away again, and

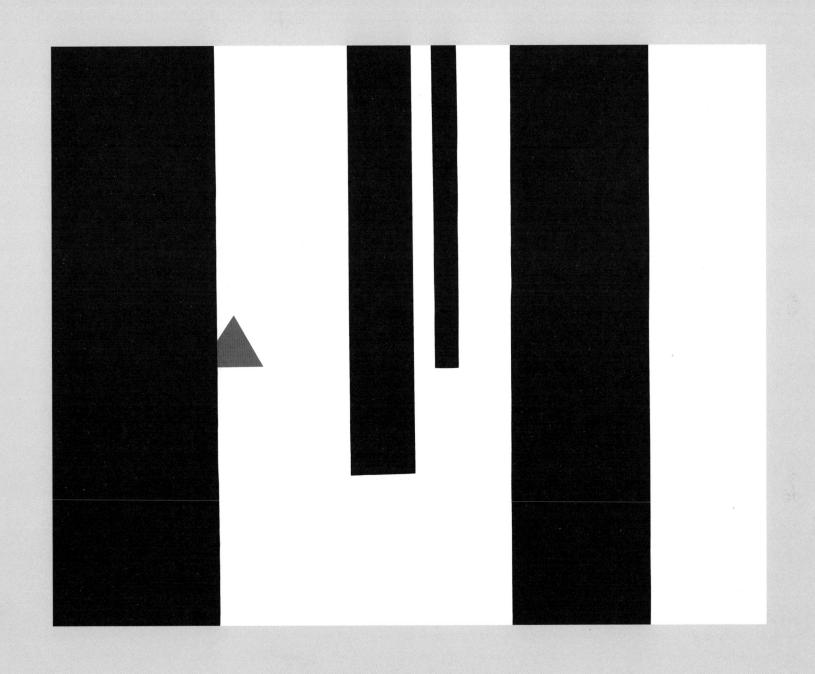

tilted some tree trunks. Now the heroine is no longer in a forest of vertical, reliable trees, but in a woods where trees might fall on her at any time.

I notice that something else has happened to Little Red Riding Hood: she is visually trapped underneath a pointed arch made by two trees. Rationally, I know that she is far back in the distance and not under the trees at all, but on the plane of the picture—that is, when I see the picture as a flat, two-dimensional space—her vertical escape is blocked by the arch, and this makes her situation feel scarier.

Also, the trees have all been tilted toward Little Red Riding Hood, effectively pushing her back toward the left-hand side of the page. When I tilt the trees away from her, they seem to be opening a path, leading her up and to the right.

The three aspects I want to point out here are:

- 1. Diagonal lines give a feeling of movement or tension to the picture, as with the leaning trees that seem to be falling or about to fall, and,
- 2. Just as diagonal strings tied around the edges of a package can secure it more tightly, the diagonal trees "tie" the woods together as a (slightly more threatening) single mass.
- Shapes that lean toward the protagonist feel as though they are blocking or stopping forward progress, whereas shapes leaning away give the impression of opening up space or leading the protagonist forward.

Enough of this forest business. It's time for the wolf.

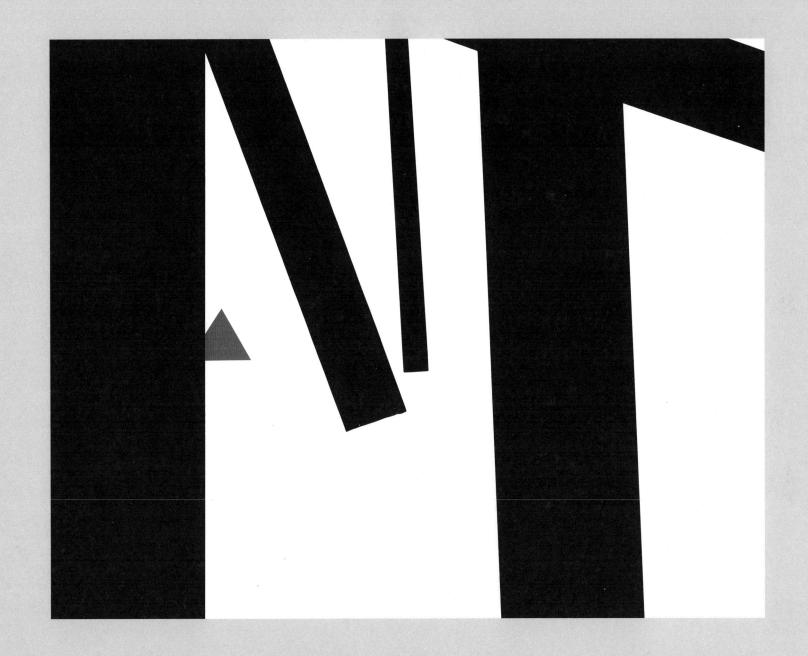

What shapes make the wolf?

Just three long black triangles.

Why do these triangles feel so scary?

Partly it's because they lean aggressively toward the left, where Little Red Riding Hood is tiny in comparison, and half hidden. Partly it's because of the context: we see the triangles as a wolf.

But I think mostly they feel scary because they are so pointy and sharp, because they are dark, and because they are so big.

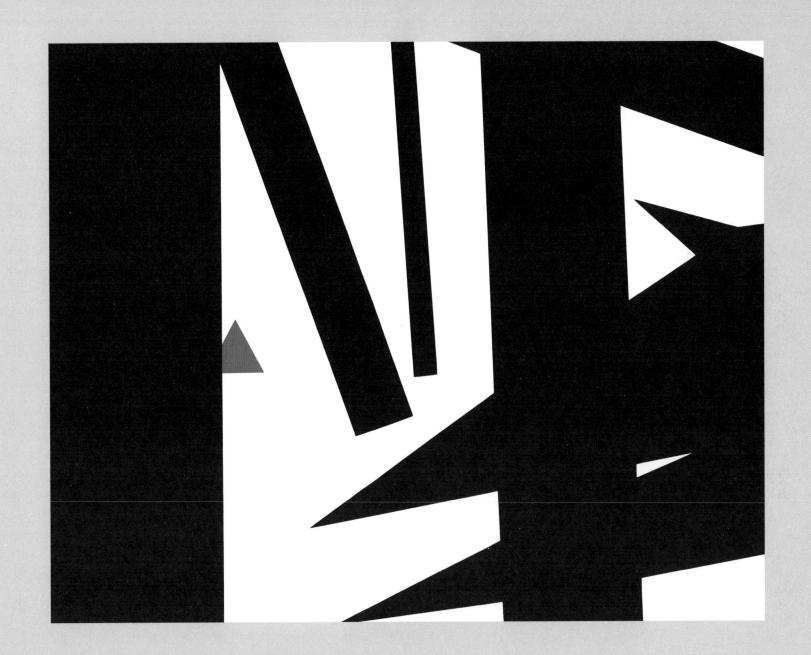

 This purple-colored wolf is a bit disturbing. The jarring disagreement between hard/sharp shape and soft color means that the viewer can't figure out what this large, important part of the image means emotionally—does it feel scary or innocuous? Dangerous or benign? Some ambiguity—enough to intrigue us—can be powerful and compelling, but take it just a little further and it becomes confusing. And we often respond to confusion with anger: because we don't understand the picture emotionally and think we ought to, we can feel stupid and rejected, pushed outside the image.

Maybe purple would be a more appropriate color if the story were about a ghost wolf—or perhaps, since I used it for Little Red Riding Hood's mother, a story about the mother having been transformed into an evil ghost wolf?

Certainly the color distinguishes the wolf from the rest of the scene. The picture has three separate parts made from three different colors, with very little cohesion. It needs to hang together better.

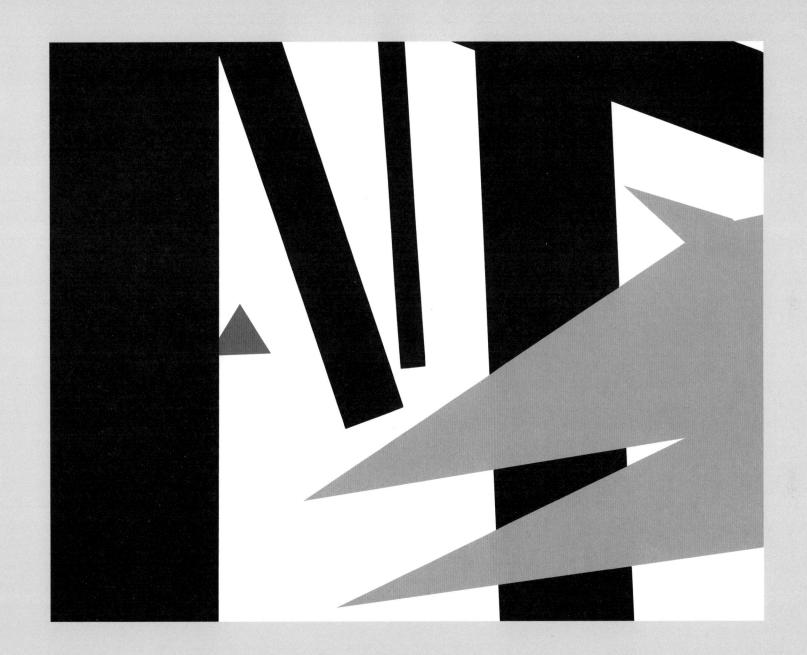

Before developing the wolf further, I need to look at it for a moment. It is scary partly because these menacing shapes could be anything now—even something much scarier than a wolf. When I add wolf details, that unknown menace will become specific, and therefore slightly less scary. But the story requires a wolf.

What are the features of wolves that make them so frightening to us? Those are the elements that I need to concentrate on if I intend to make the wolf frightening.

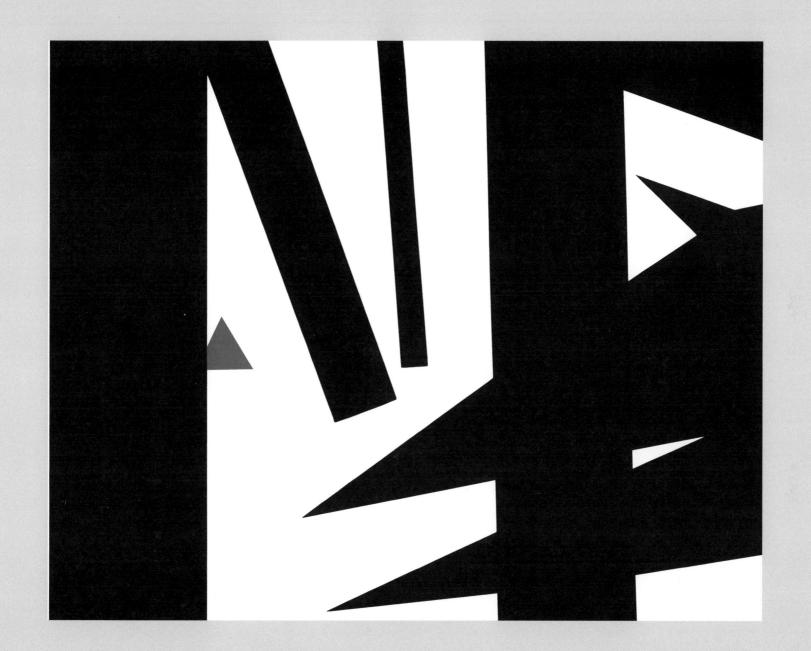

Teeth are one scary feature.

These are nothing but seven small, sharp triangles irregularly placed in the wolf's mouth. Imagine how much less scary they would be if they were rounded.

In reality, both the snout and the teeth of wolves are rounded; they are not honed to a sharp point as in these pictures. However, when we are in a scary situation, we see the scary elements in an exaggerated light: the attacker looks much bigger when we are afraid; the teeth or weapons look much sharper, just as when we are in love we tend to see the world "through rose-colored glasses."

When we want a picture to feel scary, it is more effective to graphically exaggerate the scary aspects of the threat and of its environment than to represent them as close to photographic reality as possible, because

this is the way we feel things look.

What else does the wolf need in order to look more wolfish?

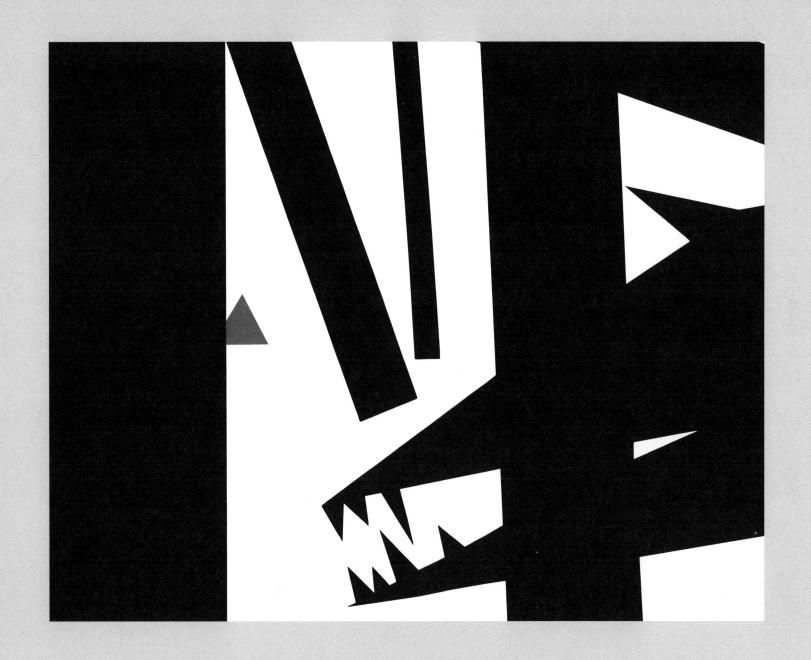

It needs an eye.

I cut the eye out of the purple paper, since there are three colors available in addition to the white, and the new color attracts our attention. Also, I wanted to use all three colors plus white in every picture.

I made the eye a long diamond or lozenge shape, emphasizing the pointiness of a real wolf's eye but getting rid of the curves.

But even though wolves' eyes are often pale blue, it didn't look right.

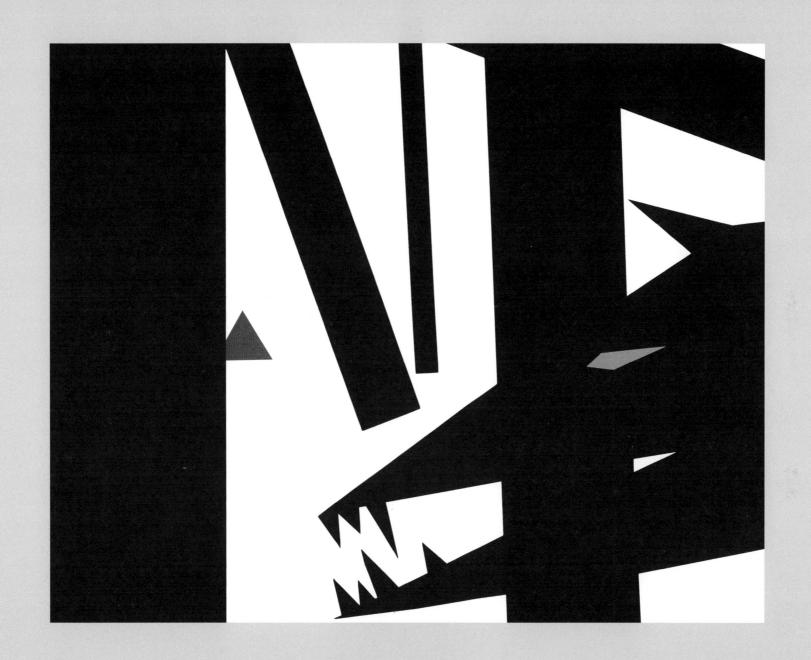

Why is this eye so much scarier?

The obvious answer is that it is red, but why should a red eye be so much scarier than a pale-purple eye?

Purple is a milder, less aggressive color than red, but why? Part of the reason may be purely physiological: somehow red excites us. Psychologists have found that people tend to get into more fights in bright-red and hot-pink rooms and tend to eat more in rooms with red walls than they do in rooms with paler colors. Part of the reason may be that we associate red with blood and fire, so this is a bloody, fiery eye rather than an eye associated with flowers or with the evening sky. Maybe it's because we've seen drunken, bloodshot eyes, or eyes reflected in a campfire, and those were red. In some fairy tales, the eyes of witches are described as being red. Red eyes are unnatural, and unnatural things make us wary. And red is an energetic color, a color with agency, so while all-white eyes are also unnatural, it is red eyes that have the energy to be hostile.

But I notice something else with the replacement of the purple eye with the red, something I wasn't expecting: I immediately associate Little Red Riding Hood with the wolf's eye, in a way I didn't before. They go together. Now the eye is looking at her.

The strong association is almost solely due to the color; when I made the eye round but still red, I associated it with Little Red Riding Hood the same way.

What happens if the eye is made exactly the same color and shape as Little Red Riding Hood?

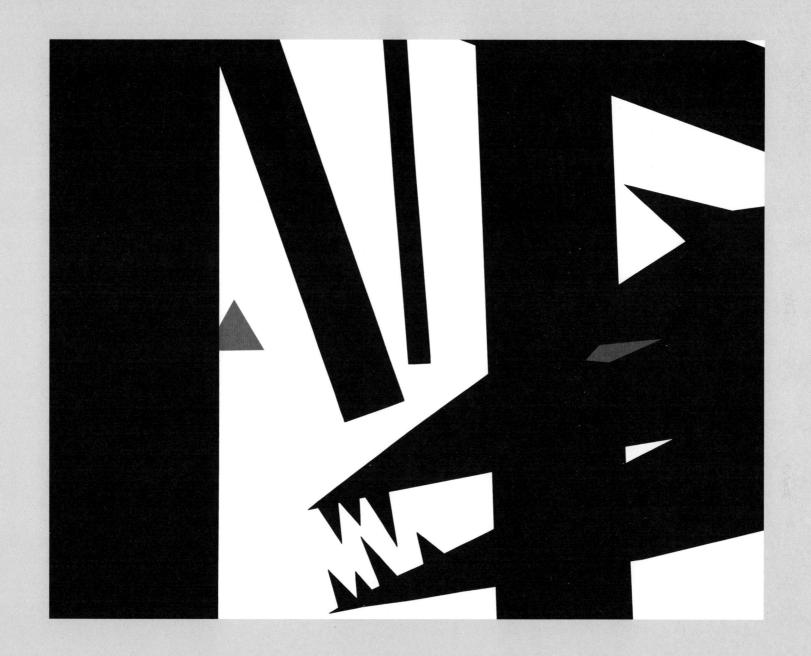

The wolf looks stupid now, or surprised, or maybe happy. Its glance is no longer pointed at its prey. Certainly it is not nearly as evil-looking as it was before. The picture feels very different, and yet all that has been changed is the shape of the eye.

A more disconcerting effect to me is that the two red triangles are now so alike, and I associate them so much with each other, that they disassociate from the rest of the picture. They are no longer meaningful elements. I see them not so much as Little Red Riding Hood and a wolf's eye now, but more as two red triangles that float up and out of the picture.

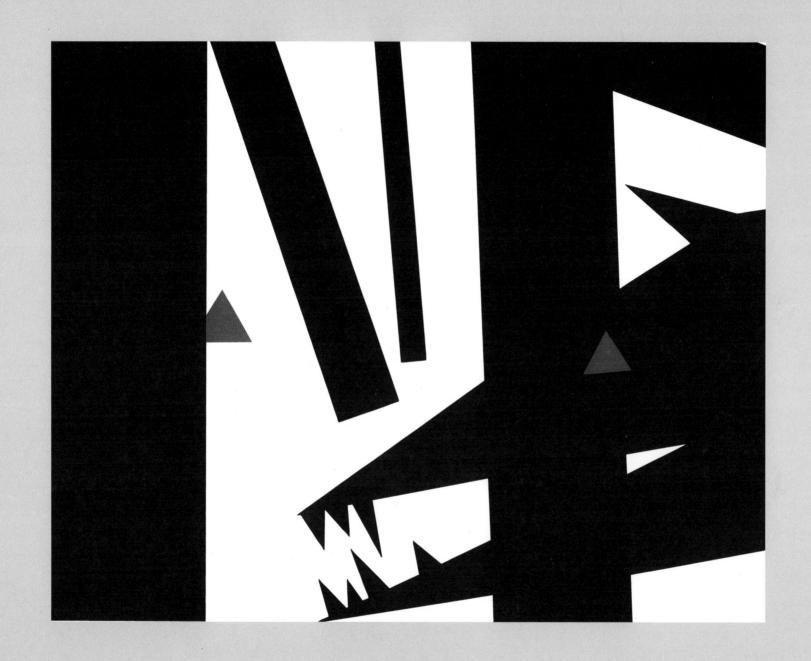

I return to the wolf with the more pointed red eye. What feature could I add to the wolf to make it yet more frightening?

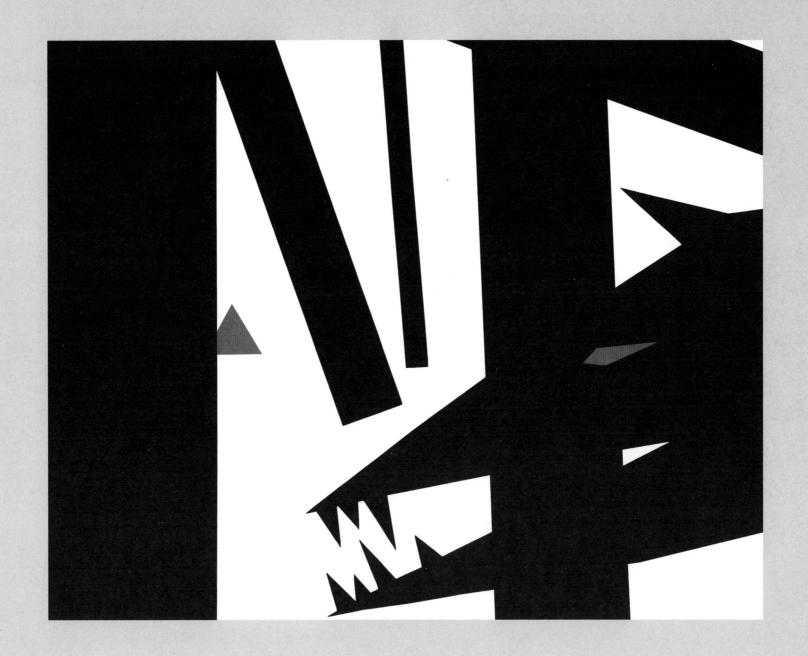

A tongue.

Now it looks as though Little Red Riding Hood is being drawn right down into the wolf's mouth, just by the force of the large red mass there. I associate her even more with the tongue than with the eye now, because the tongue is a bigger mass of red. There seems to be some sort of gravitational effect here: the larger the mass of color, the more our attention is drawn to it.

My attention is also attracted more to the wolf than to the trees—partly because the wolf is the larger mass, partly because it breaks through the verticals of the trees, and also to some extent because it is to the far right of the picture, and our eyes tend to go from left to right on the page. But its blackness keeps it "hidden" in the trees much more than when it was purple.

I see here, in a way I didn't understand before, that when two or more objects in a picture have the same color, we associate them with each other. The meaning and the emotion we impart to this association depend on context, but the association is immediate and strong. Red goes with red, black with black.

There is one more aspect of the picture that can be changed to make it feel scarier, which is

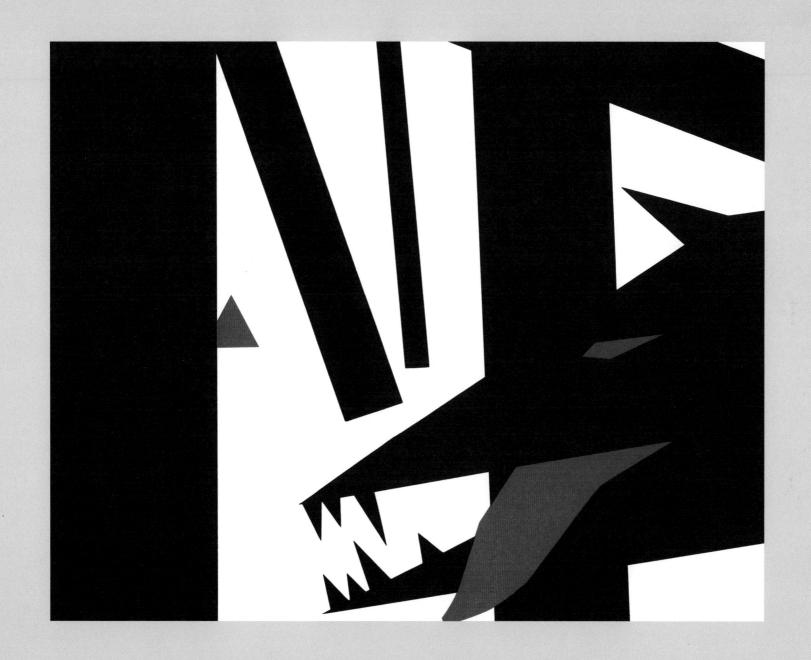

that the background can be darkened.

In the third picture in which Little Red Riding Hood was shown with her mother, purple was used as a soft, or gentle, color. It is also gentler here, in that it is less of a stark contrast with the black than the white was. Then why does this picture feel more threatening?

Because in this picture the purple implies nighttime, or deep shadow, and darkness feels scarier to us than light because we see well in the light and poorly in the dark. Darker backgrounds can imply a storm or overcast weather, which also suggest adversity or obstacles.

I tried using purple for long parallel diagonal shadows protruding from the bases of the trees, but then I got involved in how the branches, which are out of sight here, would be cast on the ground, and the shadow pattern became distracting rather than helpful. I went back to the simpler solid purple.

Now that the background is purple, how can I use white as a positive element? (By "positive element," I mean here an object rather than a background.)

The teeth.

These white teeth aren't any scarier per se than black or red or purple teeth; quite the contrary. Black teeth dripping with red blood would have been rather effective here. However, what has happened now that the teeth are white?

They pop out at us more. We notice them more than we did when they were black.

I see how powerful white is here because it shows up so strongly against dark backgrounds. The white is effective because it is used with restraint.

This picture is supposed to be scary because of its narrative content: a hungry wolf wants to eat a lone girl in the woods. But the picture was made to **feel** scary to the viewer because of the colors, shapes, sizes, and placement of the pieces that make up the picture.

How do pictures make us **feel** in specific ways?

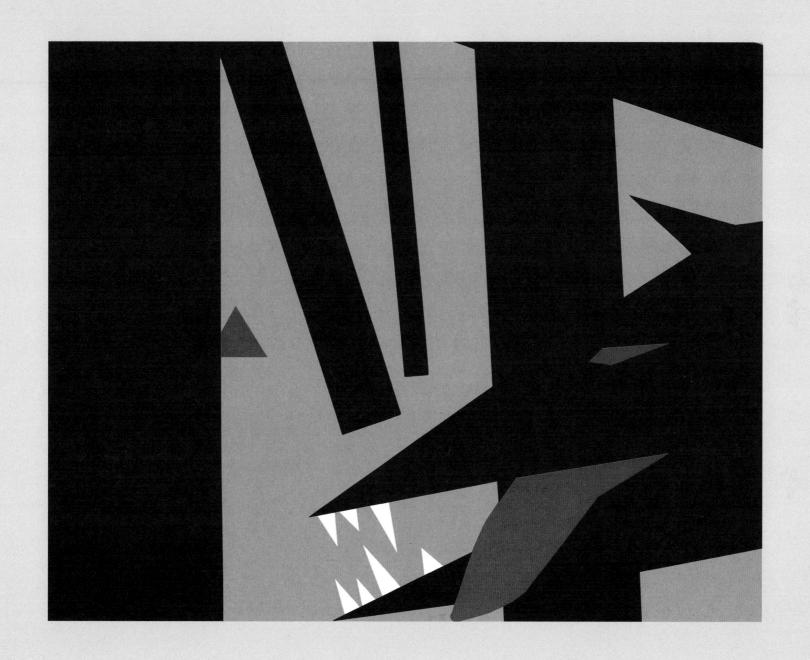

We see pictures as extensions of the real world.

Pictures that affect us strongly use structural principles based on the way we have to react in the real world in order to survive. As soon as you understand these principles, you will understand why pictures have such specific emotional effects.

You will understand how pictures work.

The Principles

I can't remember the order in which these principles occurred to me. I had read a lot and thought a lot about what went on in pictures, but largely things seemed to either "work" or "not work" for unrelated reasons. I think the principles pretty much came to me all at once, while I was playing with the Little Red Riding Hood pictures. What has taken time is paring them down to the bone. I've ordered them not in any hierarchical order, because I don't feel there is a hierarchy here, but more in the order that seemed most logical. Was it when I tilted the trees that I saw how gravity affected pictures? Whatever the reason, the first principles have to do with gravity.

Gravity is the strongest physical force that we're consciously aware of, and we're subject to it all the time. The force of gravity affects our responses to horizontal, vertical, and diagonal shapes, and it affects our responses to the placement of shapes on the page.

This all sounds very abstract, but what does it mean in concrete terms?

1. Smooth, flat, horizontal shapes give us a sense of stability and calm.

I associate horizontal shapes with the surface of the earth or the horizon line—with the floor, the prairie, a calm sea. We humans are most stable when we are horizontal, because we can't fall down. Shapes that lie horizontal look secure because they won't fall on us, either. Because of this, pictures that emphasize horizontal structure generally give an overall sense of stability and calm.

But, also, smaller horizontal or horizontally oriented shapes within a picture can be felt as islands of calm. The stability we felt in Little Red Riding Hood's triangle was due to her wide, flat, horizontal base.

2. Vertical shapes are more exciting and more active. Vertical shapes rebel against the earth's gravity. They imply energy and a reaching toward the heights or the heavens.

Think of the things that grow or are built vertically: trees and plants grow up toward the sun; churches and skyscrapers reach toward the heavens as high as they can go. These structures require a great deal of energy to build—to become vertical. They will release a great deal of energy if they fall.

Vertical structures are monuments to the kinetic energy of the past and the future, and to the potential energy of the present.

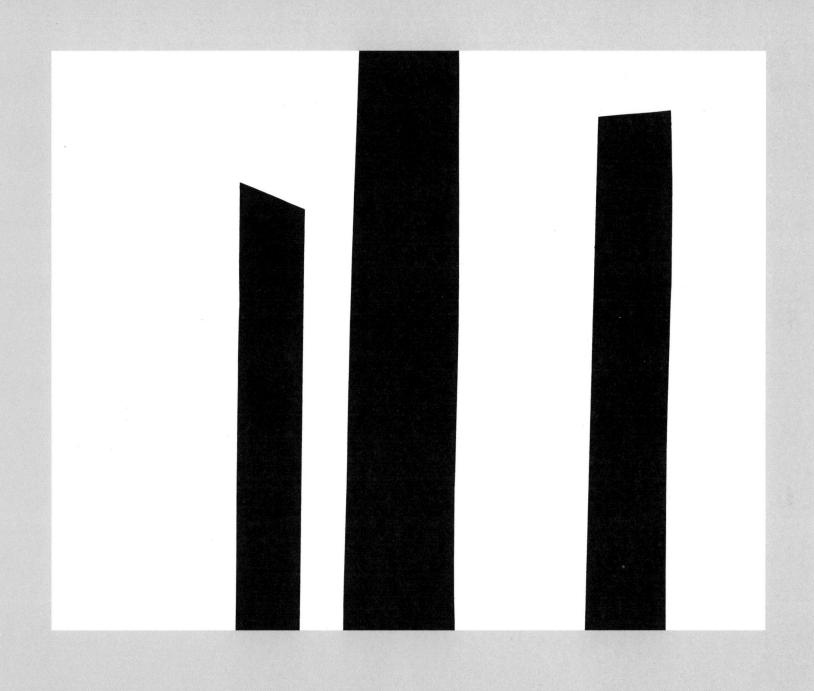

If a horizontal bar is placed across the top of a row of verticals, stability reigns again, as it does in a Greek temple. The sense of vitality and reaching toward the heavens has been checked. But the verticals give the horizontal aspect some regal quality. There is order and stability here, and the pride that goes with height.

When we change from a state of infancy to toddlerhood and rise up off the floor on two strong legs, life is suddenly much more exciting. Not only can we see more, not only are we above all sorts of things that used to be at our own low level, not only can we begin to move about faster, but also life is more exciting because

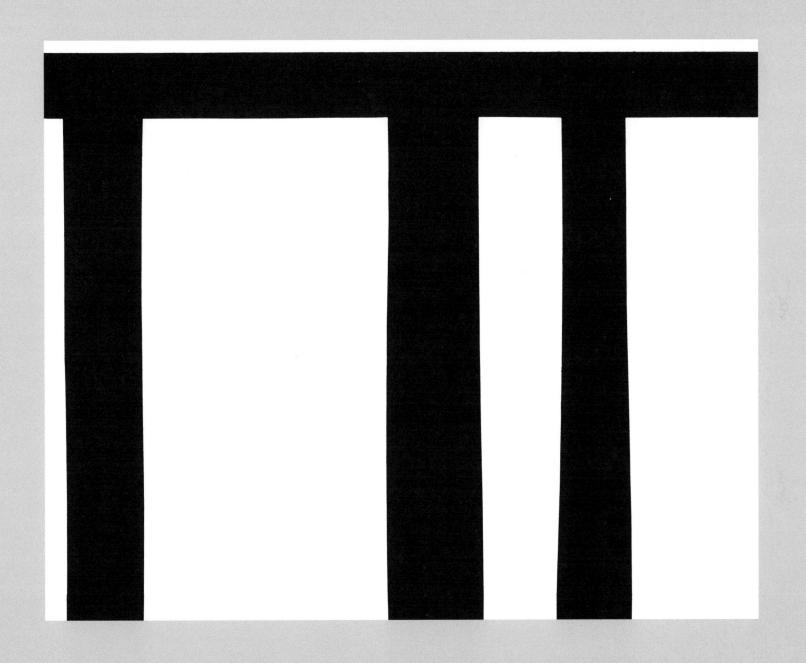

we can fall.

3. Diagonal shapes are dynamic because they imply motion or tension.

Objects in nature that are on a diagonal are either in movement or in tension.

Most of us see these diagonal lines as some sort of pillars falling. They could as easily be roof beams, supported by structures outside the picture, or parts of growing branches, pulled up toward the light of the sun but at the same time pulled down to the earth by gravity.

We can also see these bars as leading us into the picture, leading us back into space. In an asymmetrical frame, diagonals give a sense of depth.

But however we see the bars, they are felt to be in movement or in tension because they are on a diagonal.

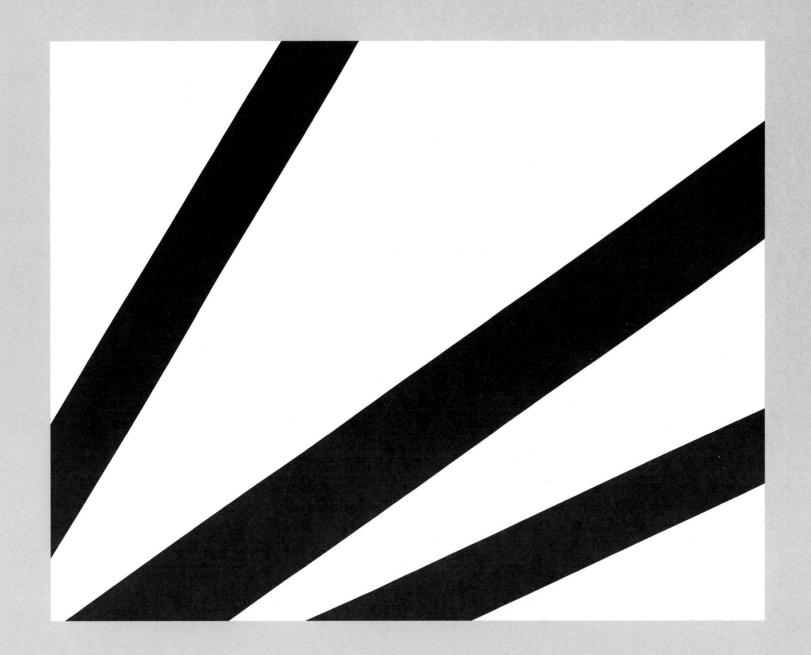

A diagonal strut holding a table leg to the tabletop gives the table stability, as a diagonal strut holding in place a vertical stud and a horizontal beam of a building ties the two securely together. The strut is under tension, preventing horizontal movement in the table leg or the stud. In the example of the woods, the diagonals tie the disparate elements of a picture together, but because we don't see them as screwed or nailed into the other trees, they seem about to fall and thus provide more emotional tension.

Diagonals in pictures often perform exactly this function.

One interesting aspect of this picture is how our eye is drawn into the white triangle—and stuck there. Once inside, I'm trapped; if there had been a break in any of the enclosing black lines, my eye would have been more free to wander out and around the whole picture.

The flying buttress is an architectural device invented to enable the builders of Gothic cathedrals to construct walls ever higher and thinner, giving from inside the church an airy, almost weightless feeling to these structures. They are diagonal elements braced between the thick outer stanchions and the relatively weak inner shell of the cathedral. If the cathedral's vaulted roof had been built on top of these walls without this additional support, the walls would have buckled outward from the pressure. This picture describes visually what's actually happening with the forces: the journey the eye takes is the same journey the forces take downward into the foundations. The weight of the triangular roof (outside the picture and pressing down on the thinner vertical wall) is actually holding the high walls in place. The flying buttress is resisting the outward thrust of the vaulting below the roof which, like any arch, is basically trying to collapse.

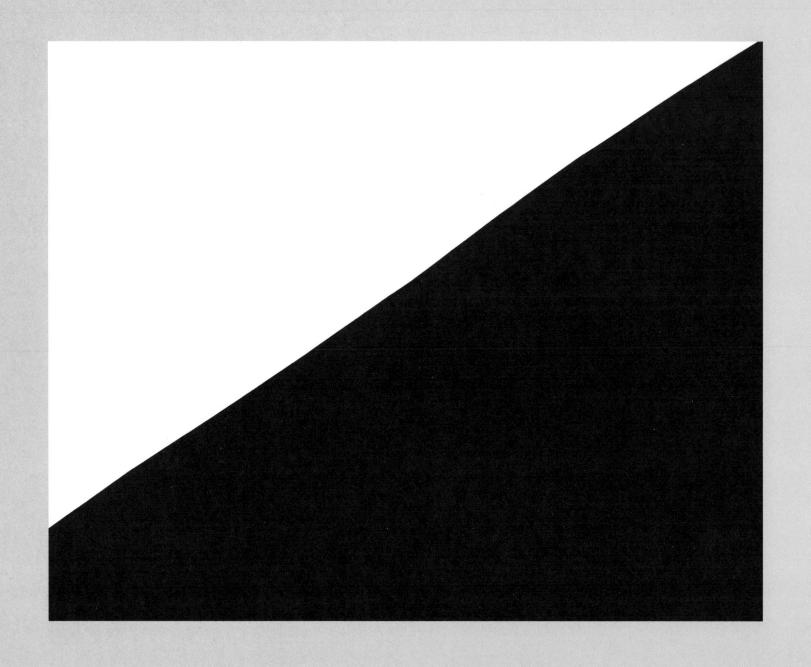

Mountains, slides, waves: all of these are diagonals in movement or in tension. (Mountains are not visibly in motion, but they are gradually being worn down to flatness—and of course most are simultaneously being thrust up from below by geologic forces.) If we imagine an object on this surface, it has to move. Even our eyes can't help moving down and up it.

Notice how we tend to read diagonals from left to right, in the same direction this book is moving, and in the same direction Westerners habitually read text.

The same triangle placed on a diagonal gives a sense of movement—whether we see it as a triangle teetering on one point, about to fall back and lie flat again, or whether we read it as a missile shooting up toward the right-hand corner of the page.

Notice how it feels as though it is floating, because there isn't any defined ground or baseline attached to it.

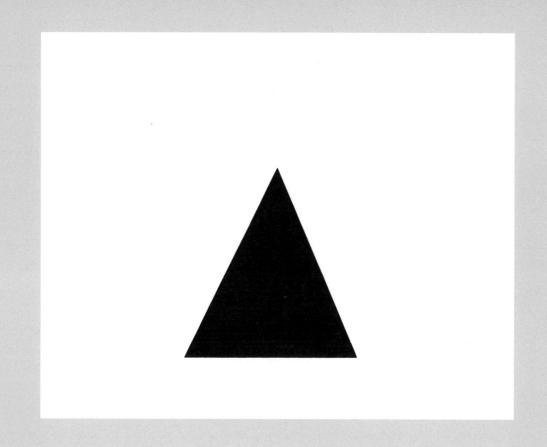

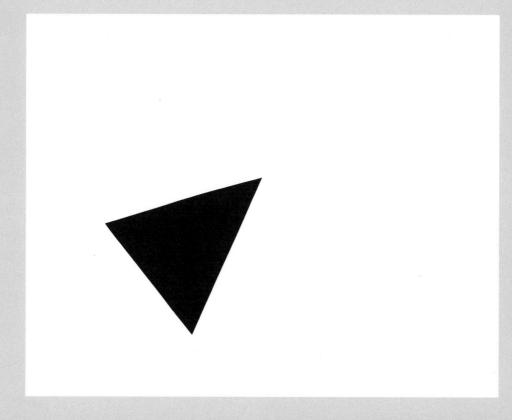

When it is made sleeker and joined by other, similar triangles placed on a diagonal and decreasing in size, it becomes part of a slew of arrows, bullets, rocks, or missiles, following a diagonal trajectory.

When I took an art history course in college, the professor one day showed a slide of a painting that featured a mass of writhing figures. The artist had dramatically lit the bodies so that a diagonal section of them stood out from the rest, which was left in shadow. The instructor talked about the "dynamic of the diagonal" shown there. The statement obviously meant something to him, and I still have a clear memory of the painting he was discussing. But I could never understand what he meant until I figured out this principle, and then that bubble of memory floated up from out of the darkened college auditorium of twenty-five years before.

It means that any picture that emphasizes the diagonal—whether with shapes or colors or light or any structural element—feels dynamic to us, because the diagonal implies movement or tension.

This picture has an even greater sense of movement because the triangles get progressively smaller and because the outline of the whole group is triangular, or arrow-shaped. When I first played with the shapes, I cut them all the same size and had them more nearly parallel to each other. They still felt as though they were moving, but the result was quite boring and heavy.

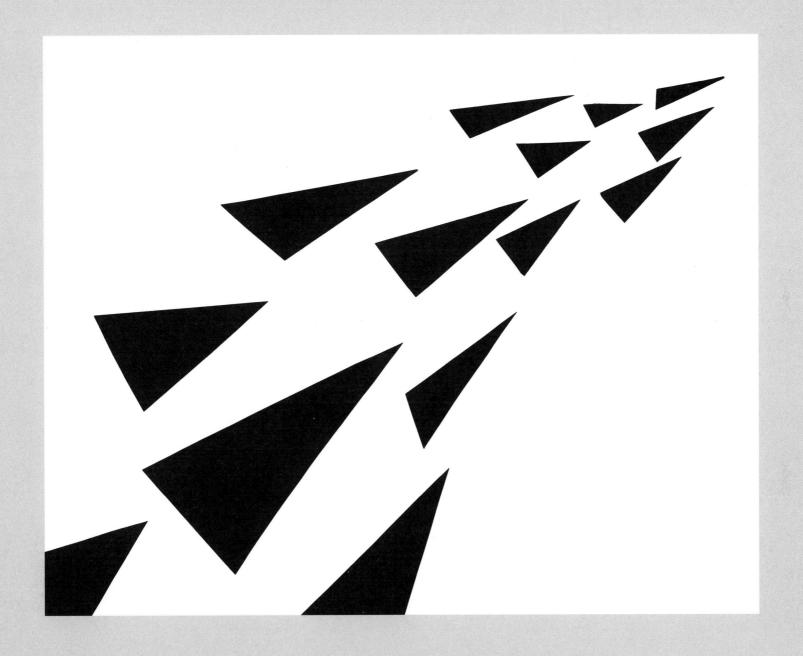

Pictures are usually read as though there is an invisible, emotional horizon line stretching across the middle of the space and dividing it into top and bottom.

4. The upper half of a picture is a place of freedom, happiness, and power; objects placed in the top half also often feel more "spiritual."

When we are high up, we are in a stronger tactical position: we can see our enemies and throw things down on them. Down low, we can't see very far; things might fall on us and crush us.

If we identify with an object that is in the upper half of a picture, we tend to feel lighter and happier. If we want to show the spirituality of an object, we tend to place it high up. Again, this is due to the force of gravity: objects that are higher up give a sense of floating or flying or otherwise escaping the gravitational pull of the earth.

Think of some of the expressions we use every day to show that we're feeling happy or have done well: "Top o' the morning to you!" "She's at the top of the charts/the class/her form," "top man on the totem pole," "top gun," "top dog," "top-drawer," "top-notch," "things are looking up," "I'm high as a kite," and so forth.

When people are said to be "high," however, it implies that they may eventually have a "terrible downer" when they "come back to earth."

The bottom half of a picture feels more threatened, heavier, sadder, or constrained; objects placed in the bottom half also feel more grounded.

Think of expressions that show sadness or failure: "down in the dumps," "feeling down," "feeling low," "low-down dirty dog," "living the low life," "lower than a snake's belly," and so on. We feel the same sorts of emotional responses to this lower position in pictures.

On the other hand, because we tend to see pictures as extensions of our world, thinking of the top half as "sky" and the bottom half as "ground," objects in the lower half of the picture feel more grounded—more attached to the earth and less mobile.

There is an odd corollary here, which at first seems contradictory:

an object placed higher up on the page has greater "pictorial weight."

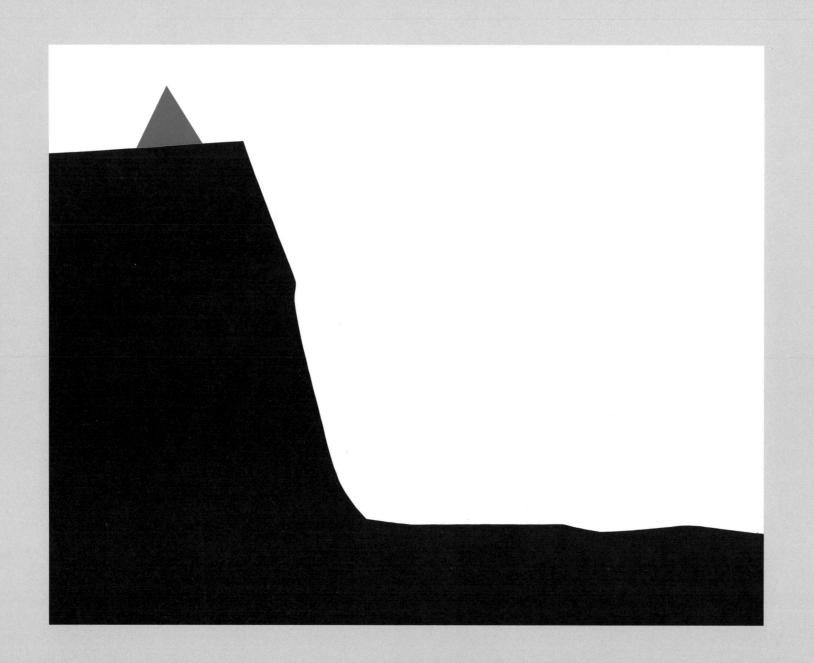

This simply means that our attention is drawn to the same object more, or it feels more important, if it is higher up than if it is lower down. We must feel that most things truly belong "on the ground," and we are perturbed when this is not the case. All other things being equal, if we want to put more emphasis on an object, we tend to place it in the upper half of the page. It tends to feel freer, less attached to the earth, and lighter, but it also has greater pictorial weight.

Before leaving the effects of gravity, I'd like to stop for just a moment to remember that

these concepts are used not one by one, but always in combination and always in some context.

Each of the principles appears quite clear when it is considered individually, but each picture we see uses a combination of principles, which makes the interactions of the parts and the overall effect more complex. The addition of each new element can modify the effect of the other elements or even change them completely.

I made two very simple configurations, to explore the way in which my response is determined partly by the content and partly by the structure of the picture, and to see how the structure can enhance or detract from the content. This picture might be of a person about to jump off a cliff, a general surveying the surrounding territory, or a lone climber who has reached the summit and is gazing back over the vista below. We feel differently about it according to its meaning-content. How does the structure enhance or detract from this meaning-content?

Of the three possibilities, the general surveying the territory feels the most appropriate to me. The figure is high on the page—that is, "up"—but it is also "grounded" on a stable horizontal. It feels stately because of its equal sides, and its wide, flat base gives it stability and calm. The points and color

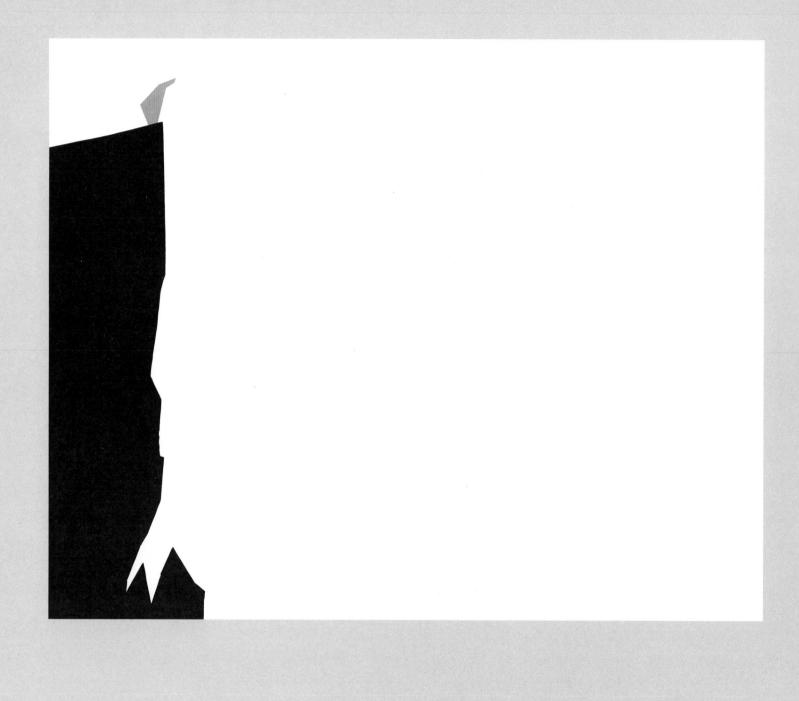

enhance its martial aspect, and the triangle suggests a cape. The cliff is high enough in comparison to the size of the figure that I wouldn't want it to fall off, but I don't feel terribly threatened. It is a good vantage point from which to survey the land and troops.

If the figure represented a climber, the land might not extend off the page to the left but instead might form a peak. It would be more effective if no low ground were shown. The figure might be smaller and in a less stately pose—either with arms raised in triumph or perhaps balanced on two thin legs that would indicate the climber's frailty and exhaustion. I also reworked it to see how it could look more like a person contemplating either jumping or the great sadness of the world. The cliff, and the ground below, are more jagged now. I cut the figure of the person smaller and thinner and made it off balance, then brought it closer to the edge and tilted it over. Red would be appropriate if the person were feeling rage and revolt. I chose the paler, "melancholy" color. (This reminds me of pictures by Edward Gorey.)

These examples are given as indications of the following: the basic principle that higher means happier or freer or more spiritual, and lower means gloomier or more grounded, is true, but the principles work in conjunction with each other, and they are subservient to context and content—to the picture's meaning.

The principles described so far result from gravity's effect on us and the world and the pictures we look at. The next principles have to do with the picture as a world of its own.

As has been said before, we see pictures as extensions of reality. When we look at a picture, we "read" it as though gravity exists inside the picture as well as outside. Most pictures are rectangular, and their horizontal and vertical edges accentuate our sense of gravity's force. (When pictures are circular, they give the impression of floating, as complete circles within a picture seem to be floating or rolling. This again relates back to gravity, though, and to our experience with round objects.)

But there are other forces acting at the same time. The rectangular frame of the picture forms a separate world inside itself. The edges enclose our attention and force it inward, and we are (usually subconsciously) aware of the rectangle's center. The frame creates a sort of visual conflict that can be thought of as a radial force, directing our attention inward from the frame to the midpoint. To some extent, but to a much lesser degree, the center of the picture also radiates energy out of itself. You can sense this even more strongly when the picture frame is square or round; then the center is so strong that it is much harder for the eyes to get away from it and move around. Yet one of the goals behind most pictures is precisely that: to encourage the viewer to wander around inside this framed world and explore it all over. If a picture is meant to be explored, it is better to keep the main emphasis away from the center.

5. The center of the page is the most effective "center of attention." It is the point of greatest attraction.

This picture can be read either as a jewel flashing with light, a heroine radiating triumph, or as a figure surrounded on all sides by attackers. Our emotional response depends on the context, but the fact remains that it is difficult to take our eyes from the center and move them around the page. They are trapped, pinned to the center.

What happens when the focus of attention is shifted away from the center of the page?

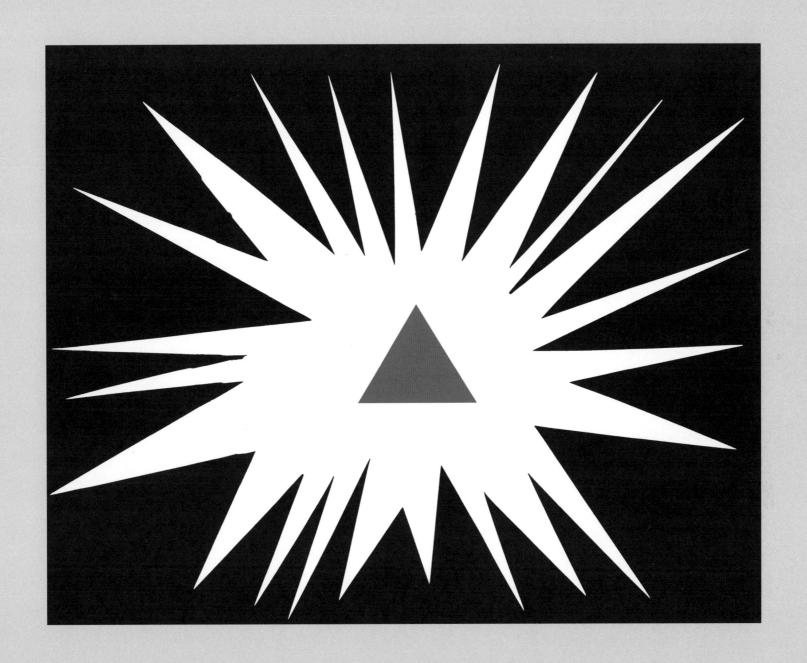

First of all, the picture is more dynamic. We feel that the red triangle is moving now, on a diagonal path either down toward the lower right and out toward us or away from us and toward the upper left. This sense of movement comes about because our eyes are now encouraged to move. We can shift along the points to the darkness at the right, which has now become a focus on its own; we move from darkness to the red triangle and back again.

Or we can move to the white space at the left—and clear off the page. Because the white area extends to the frame, the picture implies space outside itself. It breaks out into the world beyond.

But notice that with all this moving around, the invisible lines of force are ever present. We are aware of gravity as we move up and down and across the page. At the same time, we are aware of the center as our eyes go back and forth across it; we are aware of the jagged lines dividing the page down the center. The center can be used as the hub of the picture, where more intense action takes place, as an empty area of calm or incompleteness, as a divider of left from right, as the area at which two equal elements join, and so forth. But whatever we do with the center, our eyes are drawn to it and our feelings are strongly affected by it.

We are also aware of "breaking out of" the rectangular frame. Whether or not we are conscious of these forces, we are aware of them. They encourage our eyes to move in certain directions, and they affect our emotional response to what is going on.

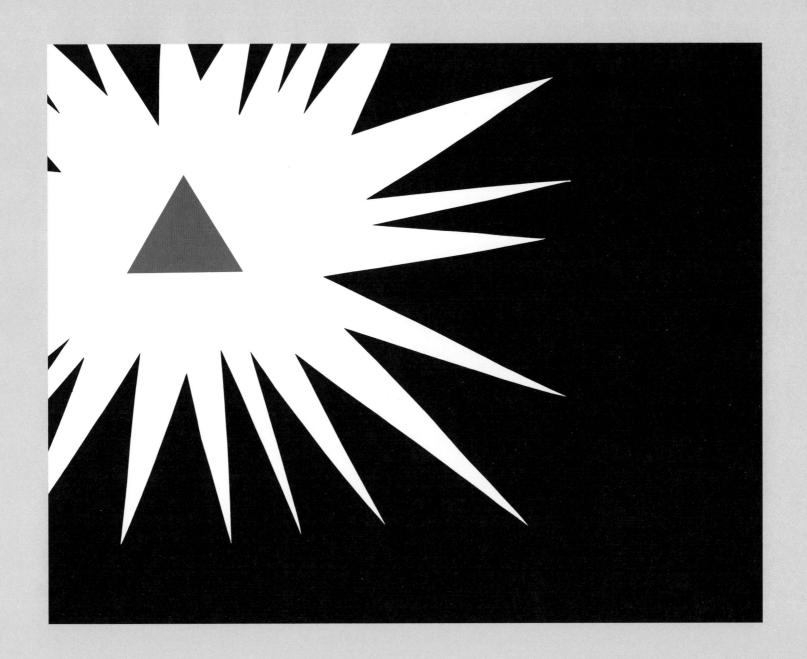

The edges and corners of the picture are the edges and corners of the picture-world.

Just as the emotional effects of high and low placement on the page have their verbal equivalents, so do the edges and corners of pictures.

"He's cornered," "she's in a tight corner," "I had to sit in the corner," and "edgy," "on edge," "my nerves are on edge," and "she's pushing him over the edge" all mean the same things when they are expressed visually.

The closer an object is to the edge or to the center, the greater the tension. It reminds me of a golf ball on a green: when it sits comfortably far from the hole, we just look at it as a white ball on the green, but the closer it gets to the hole, the more we want to push it over the edge and in.

I find that when I cover up the red shape in this picture, the space becomes much flatter. It's only when I see the red box break out of the frame that I'm aware that the other two objects can escape it, too.

Artists seldom place their figures in the exact center of the page unless that figure is meant to be an object of meditation. Visual aids to meditation, whether they be Buddhist or Christian or nonspecifically religious, tend to show the object of meditation in the center of the page so as to better enable the viewer to "center the mind."

With an object or a hole centered in the middle of the page, it is difficult to move away from the center.

Of course, a third invisible force we read into pictures is context, or story. Once we see the triangle as a little girl, we assume the things she is capable of—walking through the woods, climbing a tree out of the frame. If we saw the triangle as a plant or a mountain, we'd assume different possibilities for it: "Oh, a pretty flower in the woods! Is somebody going to pick it? Is it poisonous or a sign of spring?" or "How far away that mountain is! Will the heroine have to go all that way to get there? And it looks pretty steep if she has to climb it!" And of course there are as many narrative forces possible in images as there are sources and uses of energy in the real world. If we see these lines as activated electric wires, our eye is still drawn into the center by the shape, but we sure want to stay on the outside of the square.

The next principle has to do with light and dark. We read light backgrounds as day and dark backgrounds as night, twilight, or storm.

6. White or light backgrounds feel safer to us than dark backgrounds because we can see well during the day and only poorly at night.

As a result of our inability to see in the dark, black often symbolizes the unknown, and all our fears associated with the unknown, while white signifies brightness and hope.

There are, however, exceptions to every rule, usually due to context.

Two obvious exceptions here are that we would feel safer if we were escaping from some danger "under cover of darkness," and we would feel terrified if we were deserted on a limitless expanse of ice.

But at the same time, both black and white are "noncolors," and both represent death. When Europeans mourn a person's death, they wear black. Mourners in India and Korea wear white. We say "black as death," while we say "milk white" or "snow white." But we also say "dead white."

We associate red with blood and fire. What things in nature are either black or white? Many of them are lifeless: black night, white bones, black coal, white sea foam and clouds, black pitch or charred wood, white pearls, white snow.

Notice the way the red glows against the black. Bright and pale colors glow like jewels against dark backgrounds. Against white or pale backgrounds, bright colors often look washed out. There is a physiological reason for this: since white light is made of all the colors, all the color receptors in our eyes are activated and become "bleached out" when we see white. The black background enables the color receptors to "rest"—except, of course, in the area of the red triangle.

7. We feel more scared looking at pointed shapes; we feel more secure or comforted looking at rounded shapes or curves.

Our skin is thin. Pointed objects can easily pierce us and kill us. What do we know that has sharp points? Most weapons are pointed: knives, arrows, spears, missiles, rockets; so are rocky mountains, the bows of boats that cut through the water, cutting tools like scissors and saw blades, bee stingers, teeth...

Curved shapes embrace us and protect us.

This picture of curves can't make us any safer than can the picture of points, and we know this, but the picture of curved surfaces makes us feel more secure than the one with sharp points, because of our associations with these shapes. What do we know of that is formed from curves? Rolling hills and rolling seas, boulders, rivers—but our earliest and strongest association is with bodies, especially our mothers' bodies, and when we were babies, there was no place more secure and full of comfort.

Because of these associations, pictures with curved shapes feel more secure and comforting than ones with sharp points, which feel scarier and more threatening.

8. The larger an object is in a picture, the stronger it feels.

We generally feel more secure physically when we are big than when we are little, because we're more capable of physically overpowering an enemy. One of the easiest ways to make a protagonist—or a threat—appear strong is to make it *very* large.

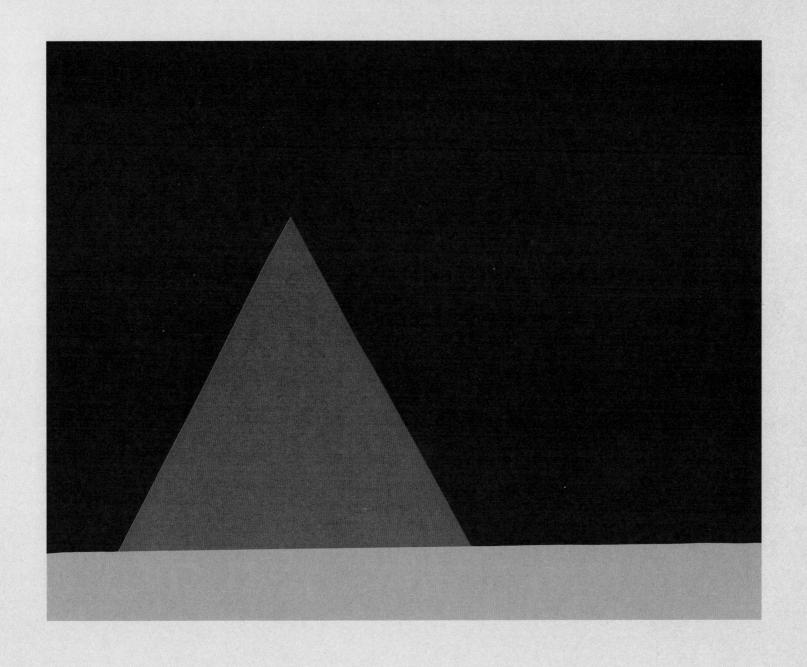

The same figure appears much more vulnerable or less important if it is made very small. If we want to show a protagonist facing a terrible danger, the danger will seem much more threatening if it is huge and the protagonist is very small. We associate size with strength—strength of any sort.

Throughout the art of India and the European Middle Ages, gods and kings were pictured very large. The lesser a god, person, or creature was in importance, the smaller their figure became.

The word "associate" is the key to the whole process of how picture structure affects our emotions. We know these pictures can't do us any more harm or make us any safer than a blank sheet of paper can, but we feel differently looking at different pictures, because we associate the shapes, colors, and placement of the various picture elements with objects we have experienced in the "real" world outside the picture.

When we look at a picture, we know perfectly well that it's a picture and not the real thing, but we suspend disbelief. For a moment, the picture is "real." We associate pointed shapes with real, pointed objects. We associate red with real blood and fire. Specific elements such as points or color or size seem to call up the emotions we felt when we experienced actual sharp points or colors or noticeably large or small things. It is these emotions attached to remembered experiences that seem largely to determine our present responses.

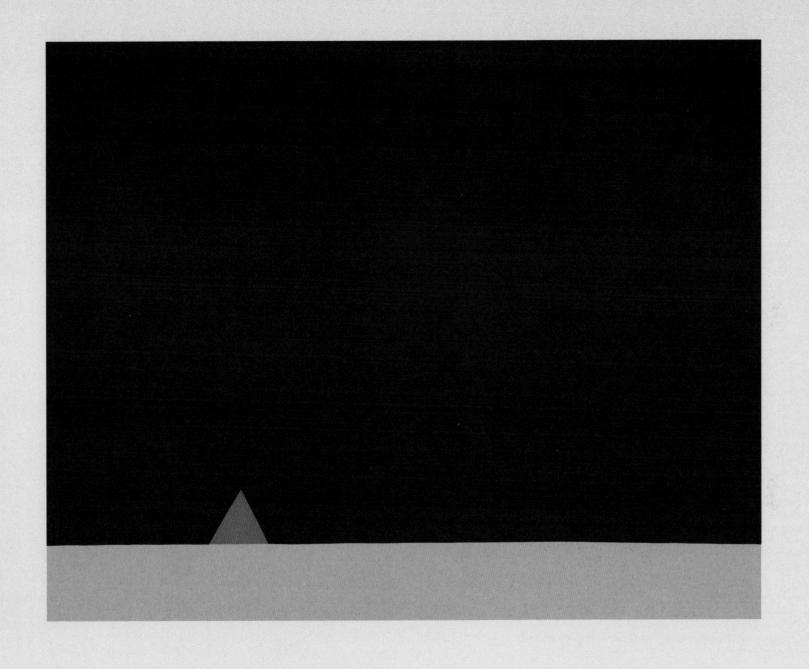

Color's effect on us is very strong-stronger than that of other picture elements.

We've already noticed that much of our reaction to various colors seems to result from our association of these colors with certain natural objects—that is, we associate red with blood and fire, white with light, snow, and bones, black with darkness, yellow with the sun, blue with the sea and sky, etc. I'll call these objects "natural constants." Now, these associations make perfect sense, and in many cases they might have helped us stay alive.

But we then go on to make an interesting generalization. Just as we assume that all pointed shapes are sharp, we assume that everything with the same color as these natural constants also shares their inherent qualities: a white swan seems more pure than a mallard duck, a red rose is more expressive of the fire of our love than a pink one, a black crow looks nastier than a cuckoo, and so forth. These secondary associations are completely false, but we make them all the time. This "symbolism of color" is part of the way we function every day. Color is one of the most powerful elements used in advertising, in storytelling, in propaganda, and in all visual fabrications. Color symbolism is based on a false generalization. And it works—very, very well.

We also associate objects of the same color when they're seen at the same time.

Pretend for a moment that you are in kindergarten, and the teacher asks you to separate all these shapes into two groups of similar elements. How do you immediately divide them?

Almost all of us instantly distinguish the circles from the triangles. In other words, we divide them according to shape. We associate like shapes with like shapes.

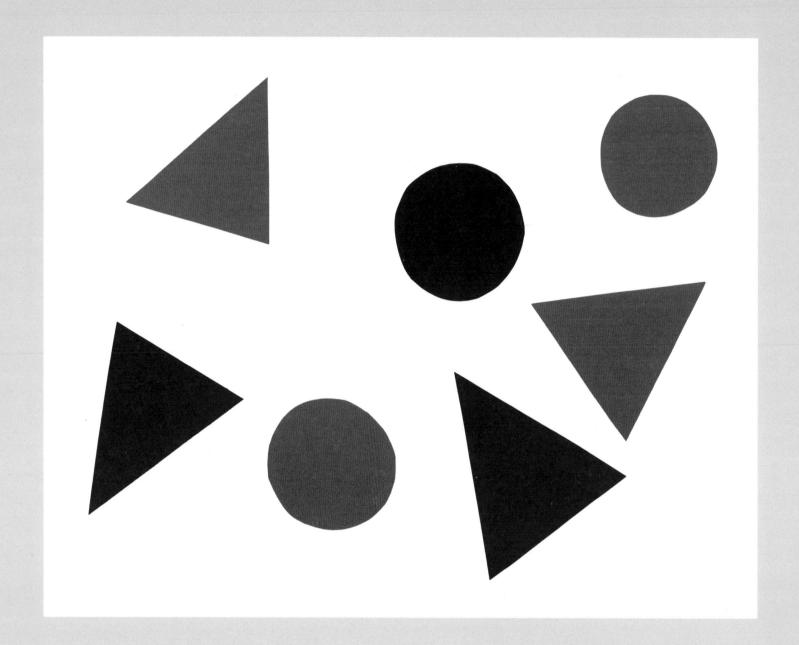

However, notice what happens when we are given the same instructions for this collection of shapes.

Our eyes immediately associate the forms by color, regardless of their shapes. We can still make groups of triangles and circles, but we are forcing ourselves to do it; our strongest association is by color. (This is not necessarily the case for small children, however: there seems to be a small window of time when they tend to make a stronger association with shape.)

9. We associate the same or similar colors much more strongly than we associate the same or similar shapes.

Our association of objects by color is immediate and very strong.

The association can be "positive," as with team players who all wear the same color uniform, or "negative," as with Little Red Riding Hood and the wolf's eye and tongue. But in both cases we associate entities of the same color, and we read a meaning into their association.

10. Regularity and irregularity—and their combinations—are powerful.

This is more difficult to talk about than the other elements because it involves patterns made by those other elements. Our eyes search for repetitive patterns, which enable us to make sense out of what we see. We notice repetition amid confusion, and the opposite: we notice a break in a repetitive pattern. But how do these arrangements make us feel?

My question is complicated by the question of "perfect" regularity and "perfect" chaos.

Some repetition gives us a sense of security, in that we know what is coming next. We like some predictability. We plant our hedges and beans in orderly rows and arrange our lives in largely repetitive schedules. Randomness, in organization or in events, is more challenging and more frightening for most of us. With repeated surprises we are frustrated by having to adapt and react again and again. Apparently the terror caused by the dripping water torture is its randomness.

But "perfect" regularity—continual, relentless repetition—is perhaps even more horrifying in its monotony than randomness is. It implies a cold, unfeeling, mechanical quality, whether human or inhuman. Such perfect order does not exist in nature; there are too many forces working against each other.

Either extreme, therefore, feels threatening. Life involves a mix: the changing seasons have a predictable pattern, but each day's weather can be a surprise; the tree outside our window might be a consistent shape, but how it moves in the wind is unpredictable—and a delight to watch. A life that is monotonously the same, with no hope of change, can be as oppressive as a life in chaos. Both threaten some form of death: of the body, of the spirit. In a picture—as in any art form—true Order and true Chaos are anathema.

The next principle involves combinations of all the others and is perhaps the most basic to our survival and our way of understanding the world—and pictures. It is simply that:

11. We notice contrasts, or, put another way, contrast enables us to see.

The contrast can be between colors, shapes, sizes, placement, or combinations of these, but it is the contrast that enables us to see both patterns and elements. Pictures—and human perceptions—are based on contrasts.

12. The movement and import of the picture is determined as much by the spaces between the shapes as by the shapes themselves.

Pictures are two-dimensional, whereas we live in three-dimensional space, with many more dimensions added by our passions and intelligence. When we translate or reform our multifaceted experience into this flat, rectangular format, we play with space.

our eyes fix on an object inside it, and we are "captured" by it. The object draws us to itself inside the picture space.

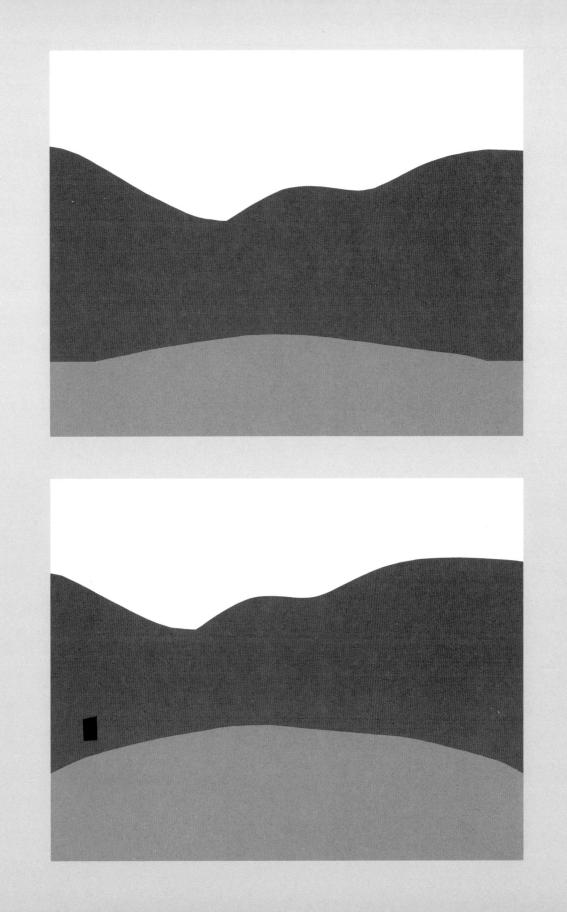

Space isolates a figure, makes that figure alone: both free and vulnerable.

The figure would stand out even more if it had a different shape, size, and/or color, but would it feel more isolated?

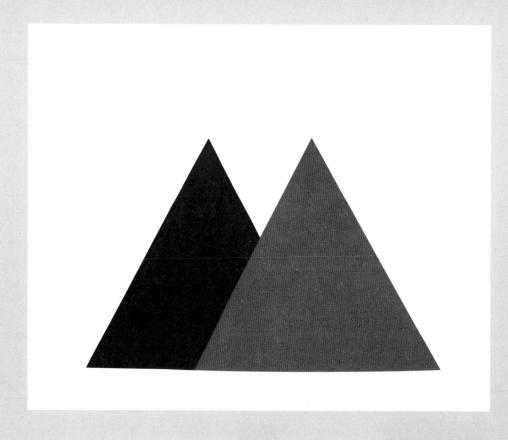

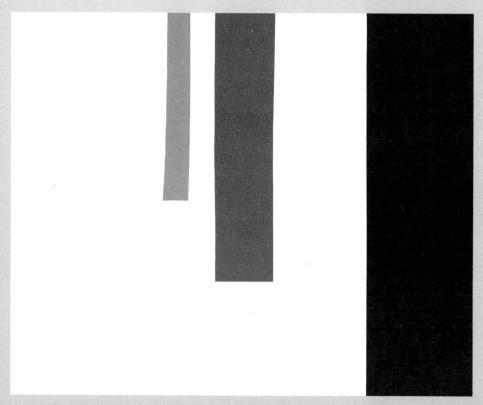

As soon as two objects overlap, the overlapping object "takes the space" of the covered one. Especially when we are beginning to make pictures, we feel this very strongly; it is hard for us to make one object overlap another. We want to leave each element as an integral piece, unbroken, inviolate. We want to allow space around each one.

The overlapping object "pierces" or "violates" the space of the other, but this also joins them together into a single unit.

A sense of depth in space is created by placing the bases of progressively smaller/thinner/lighter objects gradually higher on the page. The effect is stronger if, as the objects recede, the spaces between them decrease in a regular geometric progression rather than an arithmetic one—that is, if each space is one-half or one-third smaller than the preceding one, rather than each space being decreased by a consistent, fixed amount.

Space implies time.

This picture feels frightening to me, but part of me also wonders whether these two figures aren't just having a jolly old chat.

A threat doesn't feel so scary when it's right next to the victim, because there is no time for the victim to move before it gets devoured—and no time for us to be scared. The deed is a done thing.

I remember reading a story by Jack London in which the protagonist was dying on the icy tundra and saw a wolf sitting not six feet away. He couldn't understand why the wolf looked so completely friendly until he realized that there was no reason for the wolf to be aggressive. The man was dead meat.

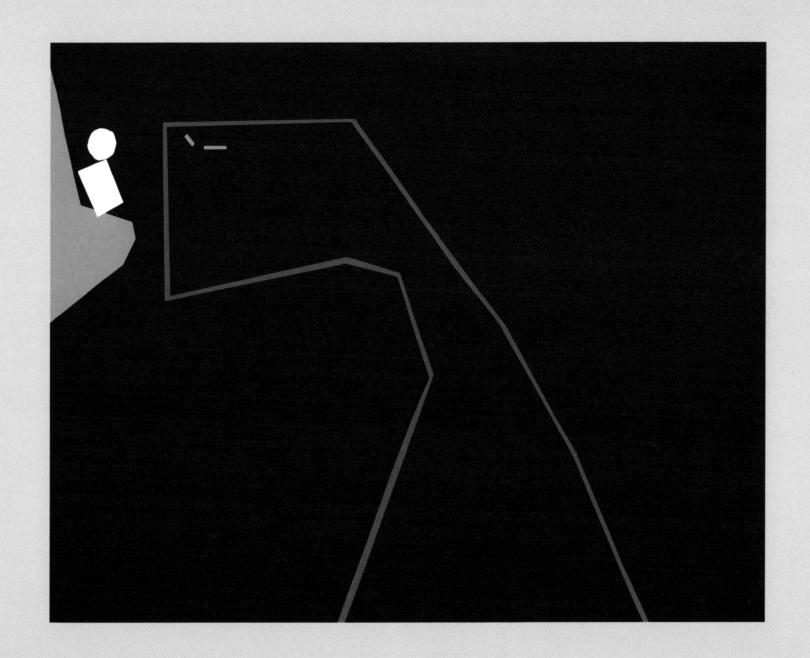

When the attacker and the victim are spaced far apart, I, identifying with the victim (which has a more human shape), have more time to be scared. There are at least two seconds now before I'll be attacked, rather than the finest split second that I had before. We might be cornered in this picture, but there is more possibility of escape with the larger amount of space-time between victim and attacker. To put it in purely formal terms, there is more tension in the picture because the objects are "on edge" at the two poles of the page, separated from each other by the vast, diagonal empty space cutting through the center, but there is no escape from the eyes or the ledge, associated and drawn together by color.

Wide space can create tension between divided objects,

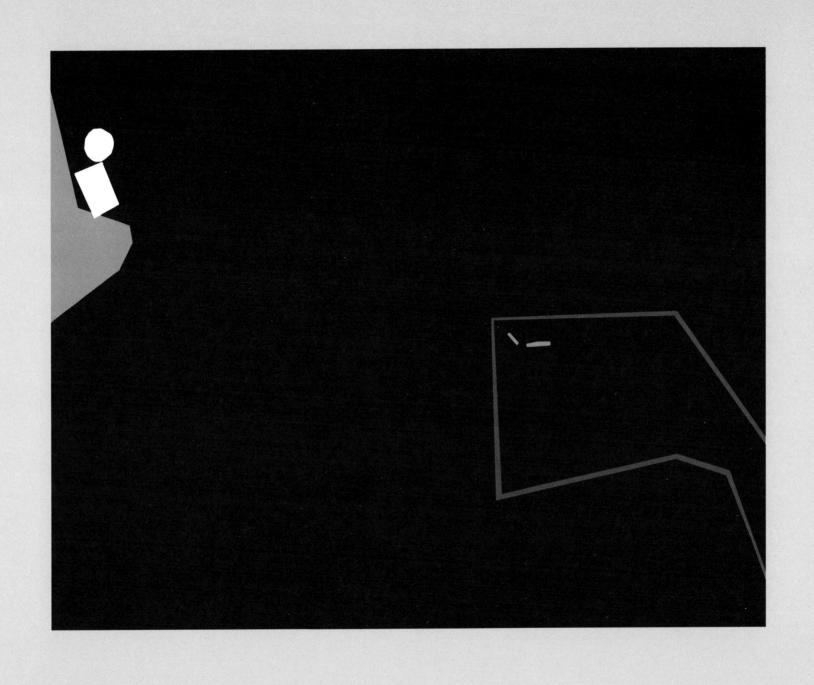

but so can a sliver of space.

As space enables us to move, so limited space makes us feel hemmed in, squeezed.

From Intent to Execution

When Sophie Gets Angry—Very, Very Angry . . . is the story of a child who is overcome with anger and who finds comfort in the woods and by seeing "the wide world" from high in a beech tree, whereupon she returns home to her welcoming family. It follows the emotional arc of a child overwhelmed by a feeling that seems to burst out of herself and take over, and how she regains comfort and security.

When I was making the illustrations, my husband suggested I decide on the emotion in every picture before I begin it, and that I make that feeling very clear. So the illustrations in this book are more emotionally charged, and clear, than in any of my others.

These four pictures do not follow one from the next, but hopefully they do give an indication of how illustrations can elicit emotions that accord with their story. It's good to remember that an illustrated story follows an arc of feeling, and the illustrations have to reflect this. One picture should lead to the next, giving a sense of flow to the whole when a book really "works."

Feeling: Fury

When children have a strong emotion, they often feel it as a force outside themselves, too big to contain. I wanted to show that in a sense it isn't Sophie herself who is angry but that she has been "taken over" by fury, so I have her fairly large and almost centered in the left half of the page, but behind her is the emanation of her feeling, that smashes the word "SMASH" to smithereens. Sophie is her normal self and color, but the Fury is pure red and double her size, its smashing arm extending over to the middle of the next page and with a smashing shape typical of comic books. The floor is angled up to enhance the movement. Think of how much less effective it would be if the floor were horizontal.

The cat isn't necessary to show the feeling, but it has the effect of stopping Fury's forward momentum and redirecting our attention back to Sophie. The cat's stripes repeat those on her shirt, and their jaggedness enhances the jaggedy feeling of the whole picture.

There is an aspect of bookmaking to notice here, which is the gutter. The split at the middle of the book formed by the binding makes every page in a picture book a diptych, and the illustrator needs to be aware of this and the way the art will interact with it. So while this is a single image, in a sense, Sophie is at the center of the left panel of the diptych, and the fist of her rage is centered in the right panel. We're aware of and affected by both aspects.

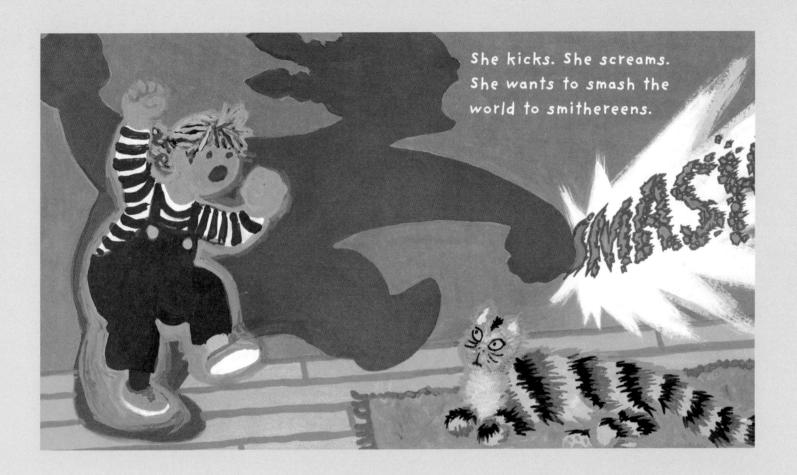

Feeling: Sadness

Sophie is much smaller here, and the scene is now of darker colors, though some of the trees she has passed are outlined in red, associating with and showing traces of her former fury. I outlined almost everything throughout the Sophie pictures. In this picture, the red outlines around the trees and around Sophie suggest her fading anger, but I think her red outline is also an indication of her basic vitality, as is her blue and white striped shirt. The same thing holds for the next two pictures: Sophie continues to be outlined in a vital red, and the white stripes of her shirt add energy.

In nature, when we look at an object against a dark background, our eyes create a nimbus of light around it, while the edges of an object look darker against a light background. You'll notice that artists use this effect in most any good "realistic" Western painting. The Sophie pictures are not meant to be realistic and don't use this technique. The outlines are there to infuse different energies into each picture and to separate the objects, as well as to relate them either to each other or to Sophie.

You can play with outlines when making your own cutout pictures by cutting a piece of different colored paper slightly larger than your figure, and placing it behind the figure itself. This usually has the effect of "popping" it out.

Sophie has crested the hill now and is walking more slowly on flat ground, having spent her angry energy. Above her the trees bend in sympathy with her bowed form, as do the ferns below her path, so the whole picture has a sense of the weight of sadness and evokes the same sympathy in the reader. At the far right, the vertical tree stops her forward motion, slowing her even more, but also giving some relief from the "crushing" of the other trees, as well as hope for an alternative future—which will come in the next pages. Notice how Sophie is isolated—by her size, her colors, and the large swath of plain color behind her. This reinforces how alone her emotions make her feel.

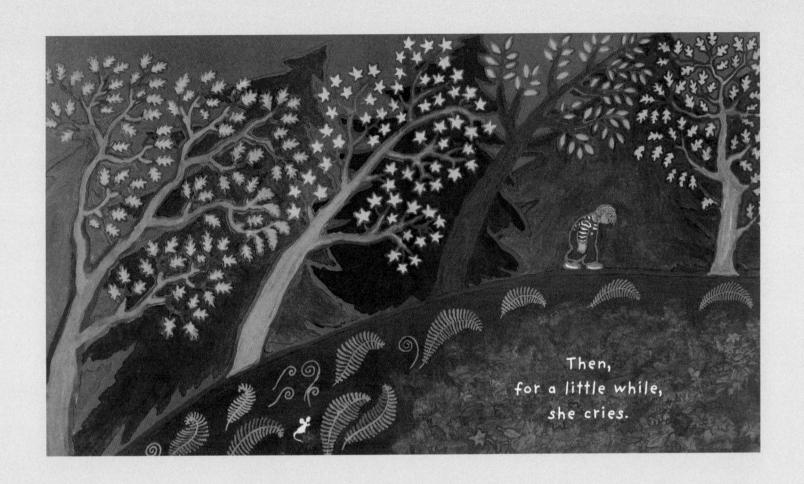

Feeling: Expectancy

We can sure see the power of the diagonal here, with the beech starting big and wide where Sophie stands and diminishing as it grows into the sky—like a path, a ladder pulling us up to the cool blue. The background trees curve in a gentle protective arc around her. I wouldn't call the curving branches exactly comforting, but they feel almost alive with energy. Notice that Sophie tilts slightly forward at the same angle as the tree, as do the background trees; they are aligned and therefore allied with her. Sophie belongs here. The whole picture is urging her, and us, into those upper right-hand branches.

The line of the horizon is important here. It bends to end up essentially perpendicular to the tree's direction, both grounding us and embracing Sophie. Horizon and tree start to look like a shore and a bridge leading Sophie's shape to a new place. Both in this picture and the former one, the leaves form a filigree over the page, which softens the basic structure and to some degree hides it. But we know it's there.

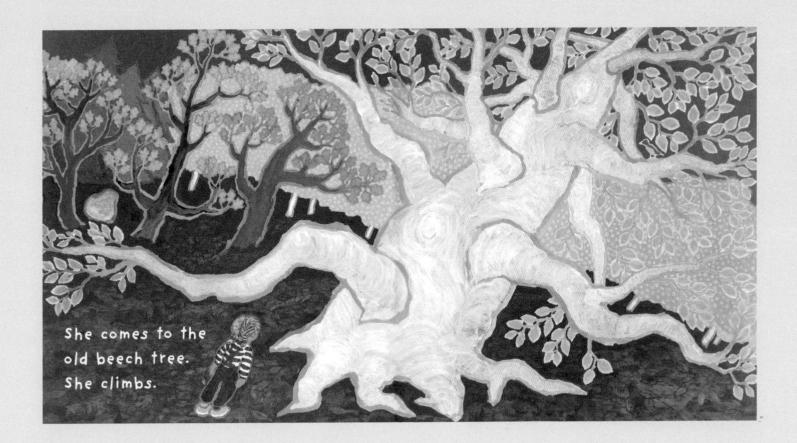

Feeling: Contentment, contemplation

Sophie is a stable little rounded triangle sitting just below the midline of the left-hand page and just about at the center of it—solidly centered there, with the rest of the page devoted to the wide world. She sits nestled inside the crotch of a fairly straight trunk and a thick curving branch. The tree is clearly the same tree as in the previous picture, but now the branches curve up to cup and enfold her, while from above another branch curves over her head, protecting her. The distant curve of the beach far away points back to her, also protective but bringing our attention back as well. The horizontal line of the sea grounds both Sophie and the picture. Small in comparison to the wide world, she is still far bigger than all the visible aspects of humanity. Clearly her red outline no longer denotes fury, but instead her basic vitality, and it associates her with the sparks of life in the red houses, the red sailboat, and the red bird.

In a sense, the tree and its gestures are an outward representation of Sophie's control over and understanding of her own emotional state. The tree is the vast inner steadiness that she can find in herself. The wide blue ocean and flat horizon also suggest a view into her own calm.

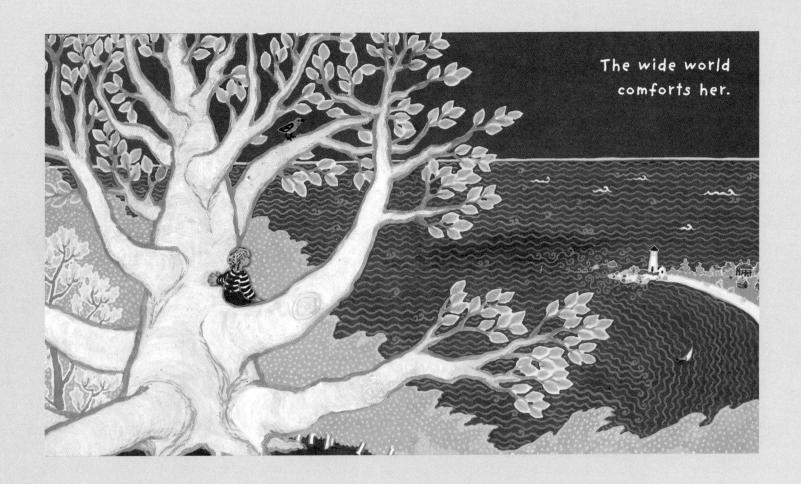

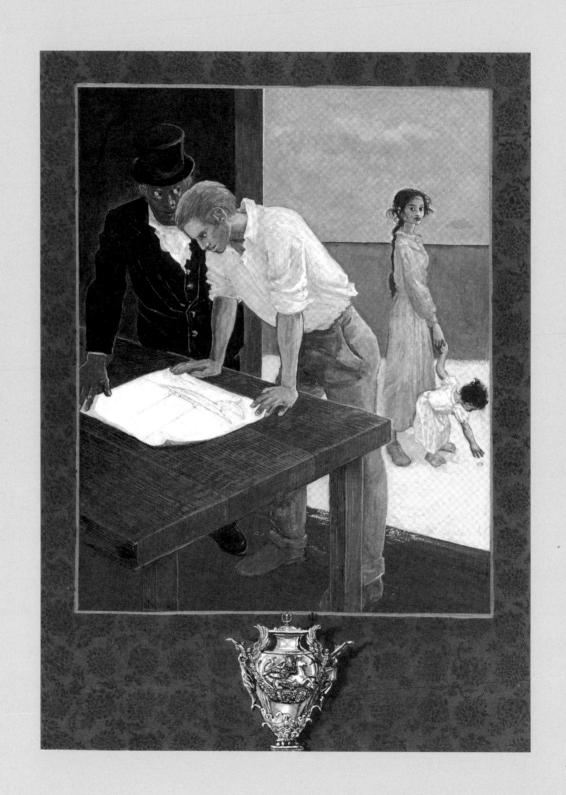

Finally, in Defense of Instinct

I'll end with one of my favorite illustrations, from the book Dawn.

I adapted this story from a Japanese folktale, "The Crane Wife." In my version, a shipbuilder rescues a Canada goose, which unbeknownst to him returns as a woman, a weaver of sails. He marries her, and she gives birth to a daughter they name Dawn. She also weaves him a set of sails "so soft and yet so strong they called them wings of steel." A rich yachtsman asks the man to build him a racing yacht, with sails like their "wings of steel." The mother refuses, saying it would take too much out of her. The father demands, and the woman gives in, asking her husband to promise never to come into the room where she is weaving. At the last minute he breaks his promise and finds a Canada goose "plucking the last feathers from her breast." The goose flies off and is gone.

The illustration is of the rich yachtsman and the father looking at the plans for the yacht, while the mother looks on from outside the building. The frame is meant to imply the wallpaper of the yacht club and the prize the boat will be competing for.

I made this image long before I wrote *Picture This* and before I understood its principles. And yet this remains a favorite image, and now I understand why. I won't try to deconstruct the picture, but as you look at it, see how the principles were used and how they affect your own feelings. And as you go forward, remember that the tools of analysis in this book are ways of expressing the instincts we all have in common, but that as an artist it is your own instinct that will lead you as you make illustrations.

Now . . . Begin

Why is cut paper such an effective tool for exploring picture structure?

First, construction paper is cheap, and it is familiar. It is easy to work with and eminently nonthreatening. For many of us, cutting construction paper takes us back to nursery school or kindergarten again—to a time when we got absorbed in the task at hand, with little thought of anything beyond the Right-Now-I'm-Making-This. It was a time of great absorption, or "flow," a time when we all knew we were artists, or rather, when we didn't worry about it one way or the other because we were absorbed not in who or what we were, but in what we were doing.

Second, working with cut paper encourages experimentation. Every piece of paper can be recut, repositioned, or replaced with a different piece or pieces. We can play with a single element while the rest of the picture stays exactly the same, and we can see how various changes in that one figure affect the whole. Cut paper is a perfect experimental tool, enabling us to play with picture structure in a way no other medium does. No paper shape we put on the page is "final" in the way a stroke of paint or marker or even pencil is. A picture of cut pieces of paper becomes final only when we paste the pieces down—which is why nothing should be glued until we're really satisfied. Playing with paper is making a series of controlled experiments.

Last of all, cut paper makes us concentrate on structure, emotional clarity, gesture, and overall cohesion rather than on line, detail, "realism," or shading. Cut paper keeps us to the emotional basics.

Exercise

Bird(s) or Shark(s) Attacking a Victim

I suggest a scary picture as a first exercise, because for most of us, a scary picture is the easiest to make. And I suggest that you begin by working in a group, which is much more effective than working alone. Also, the more I've taught courses using *Picture This*, the more I find that people learn better from contrasting situations—so it's good to have some individuals working on sharks and some on birds. Both sharks and birds can be scary to us, and the pictures will involve many of the same principles, but they will also use different shapes and picture structures, which are helpful in understanding effective variations.

Use only cut paper—no lines, no drawing the figures in pencil first and then cutting out the shapes. Work solely with paper and scissors, using three colors plus white. Have everyone use the same three colors plus white, so you can get a sense of the range of variation within these limits. Keep the shapes as simple as possible, concentrating on shapes that elicit an emotion or a sense of fluidity or flight rather than on the realistic representation of body parts. Use one color twice to show a meaningful association between two elements, like Little Red Riding Hood and the wolf's red eye and tongue, or the black wolf and the forest.

Before you begin, ask yourself two sets of questions:

- 1. What is the essence of the person/creature/thing I want to represent? What specific elements in this situation evoke fear in me? How can I accentuate these?
- 2. What principles might I use to evoke fear in a viewer?

The first questions deal with the subject at hand, the second with emotions and principles. List the structural elements most essential for each category; in this case, you want to make the attacking

bird(s) or shark(s), and you want to evoke fear. Keep returning to these questions when your picture doesn't seem to be working. The solution is almost always in one of the two categories.

Revision

Before talking about analyzing your picture, I need to say something about details.

I've noticed a pattern that keeps repeating itself in student work: in the first or second revision, many students add details that distract from the emotional impact. The addition of these details might be from the relief students find in not having to work only with big pieces of construction paper, or relief from the emotion they've been concentrating on, or the impulse to decorate a picture that feels more powerful than they expected from themselves—an impulse to make it "pretty."

Making powerful, effective pictures comes first. Adding wispy seaweed to a picture in which a shark is about to attack a swimmer or a little fish will distract from the sense of fear...

Or it might enhance it. And that's the question we have to ask ourselves when we add details: Are these specific details helping to enhance the meaning or the emotional impact of the picture, or are they a distraction? Does the wispy seaweed make the swimmer look safer and therefore make the shark attack feel much more unexpected and therefore scarier? Maybe the wisps partially hiding the little red fish make it appear like the fish might escape, while simultaneously the connection between the red fish and the shark's red eye make us fear for the fish. Or maybe the thin curvy lines just make the whole picture busier and less effective?

When I see the use of details like this, I often ask the student to get rid of them and see what happens to our response. Sometimes, the response is much stronger without them. But what's fascinating

about the exercise is simply noticing whether the details enhance the emotion or distract from it. The questions to be asking yourself continually are:

What does this element add to the picture?

Does it help the picture feel stronger, or does it dilute the emotional message the picture is trying to convey?

Does this clarify what I want to say or does it distract from it?

Analysis

When you feel you have done as well as you can, review each picture with the same questions in mind:

Does my picture communicate "attacking bird(s) or shark(s)"? Have I used the principles to evoke the feeling I want?

When we are just beginning, we often constrain our pictures in many of the same ways: we make all the elements fairly similar in size; we tend to use the center of the page and avoid the sides; we tend to divide the space into regular sections; we tend to go for realism rather than essence; and we tend to use only two or three of the applicable principles rather than all of them. And very often we sacrifice emotional impact for "prettiness."

Do not worry about whether the picture is pretty. Worry about whether it is effective, and review the picture with this in mind. If the attacker is big, make it twice as big, and the victim twice as small. See if you can break out of the picture frame: can the attacker be so big it doesn't fit on the page? Can

the victim be sitting on something that extends off the page? Look at the amounts of space between the side of the page and the victim, the victim and the attacker, and the attacker and the other side of the page. Shift the pieces around to try different amounts of space around and between them. Do you want to "corner" your victim or isolate her/him? Does the attacker break through the picture frame or engulf it? Show that the attention of the bird(s) or shark(s) is focused on the victim.

If it is a bird, does it look like a sweet, plump, delicate, realistic silhouette of a sparrow, or does it look like a creature of flight, with nasty eyes and a dagger-sharp beak? Or does it have a hooked beak, with clutching talons, or is there a whole horde of sharp, dart-like creatures all aimed at one point? If it is a shark, is it a huge, finned monster of doom? Or is there a surrounding, inward-twisting swirl of fluid forms? Which situation would most frighten you personally?

Restrict yourself to the aspects of birds or sharks that most frighten you. Forget the others. If you are most afraid of talons, concentrate on making those scary, and ignore the beak. If you are most afraid of engulfing, suffocating wings, concentrate on those and make them huge, overwhelming, jagged and all-encompassing. Skip the claws and the tail feathers. You don't need to put in all the elements of a creature, just the aspects that frighten you most.

If for some reason you can't remember what a bird looks like, go to a place where you can observe them, live. Look not only at the tiny details, like how the claws are formed, but also at how the birds move, and see if you can translate those movements into the simplest geometric shapes. If you can't find live animals, use pictures and photographs. Don't concentrate on highly realistic renderings; instead look at abstract paintings of birds or sharks, and of flight and movement. In every case, look for the essence and for what you feel and why.

Finally, go over each of the principles you have used and see if you can intensify them. If the beak is sharp, cut it in half to make it more pointed and see if it is even scarier. If the background is light, see how it might look if it were bold or dark. If the attacker is high and the victim low, push them even farther apart, to their limits, or reverse their positions. Review the other principles to see if there

are aspects that you may have overlooked. Push the pieces of your picture around. Cut new ones. Replace one element with a piece of the exact same shape but another color. This is your private puzzle. Experiment with it.

Do not glue down the pieces until the whole picture really works. "Okay" is not good enough. You ask, "How do I know when a picture 'really works'?"

When a picture works, you and/or the others will know.

Further Exercises

- 1. Choose a painting that you particularly like. Placing the elements exactly, translate the painting into an abstract composition using only rectangles, circles, and triangles and three or four colors, to learn how the structure works.
- 2. Represent a situation that evokes a strong emotion: snake(s), shark(s), rat(s), or spider(s) attacking a victim; a parent and child with water; people dancing; a child giving food to animal(s); a person watering, tending, or planting plants; a person trapped in a cage/dungeon/flaming forest; a person triumphant upon conquering a bear/army/mountain. I've often found that it's easier to do two pictures with the same subject but different feelings at the same time: birds attacking a victim and (almost) the same figure feeding a bird or birds; a person walking in a scary forest and the same person (with slightly different shape, size, etc.) in a safe landscape, etc. Students are able to see the differences more clearly when they have two pictures to work with.
- Illustrate a poem or series of poems, using the same three or four colors but representing different moods.

- 4. Illustrate a cover for a book, or a poster for a movie. Ask yourself the same questions as for the other pictures, but add a further question: How can I most effectively use the letters to enhance the feeling I want to evoke? Look at how words are used on a variety of poster and book covers.
- 5. Illustrate a folk tale or short story, again using the same limited colors throughout, eliciting appropriate emotions for each of five or six scenes. Try making the first and last picture similar to each other but different, to give a sense of coming full circle but with changed feelings. Be sure to make a cover as well.

In each case, it seems most helpful to represent a situation that would particularly affect you personally. One of the most powerful "bird attacking victim" pictures I've seen was made by a woman who had been attacked by birds while rock climbing. One of the most powerful "parent and child with water" pictures was made by a woman who for the first time had left someone else to care for her ten-month-old child. One of the most moving pictures of a figure in the wilderness was made by a man who had just returned from two weeks walking alone in the desert.

Playing with cut paper forces us to concentrate on the basic structure and on how this structure affects our emotions. But this is the basis for all our visual art forms, the foundation on which the rest is built. Once you understand how these principles work with paper, you can use them in any medium.

I believe the principles in this book are grounded in our instinctive responses to this world that both sustains and threatens us, but these principles are a work in progress. Art is a way of communicating our feelings about the peculiar and awesome situation of being alive, and as various as those are, so are our ways of telling each story.

And now it's your turn.